THE MOONLIGHT GARDEN

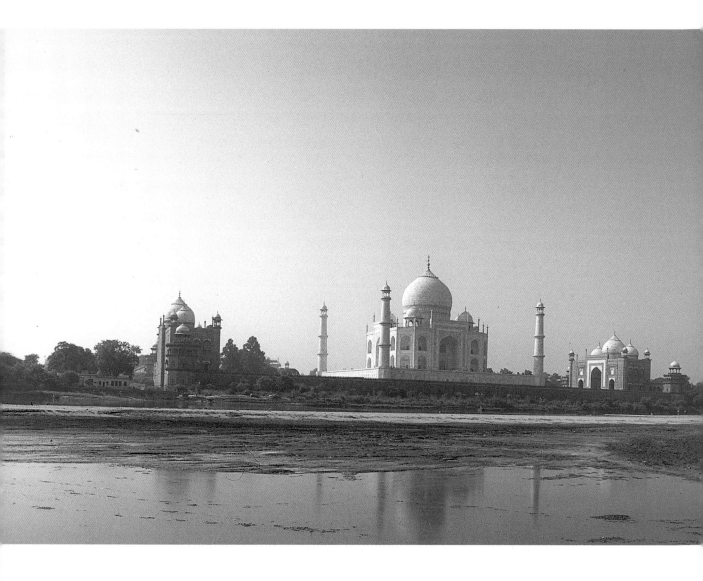

# THE MOONLIGHT GARDEN

## NEW DISCOVERIES AT THE TAJ MAHAL

*Edited by* ELIZABETH B. MOYNIHAN

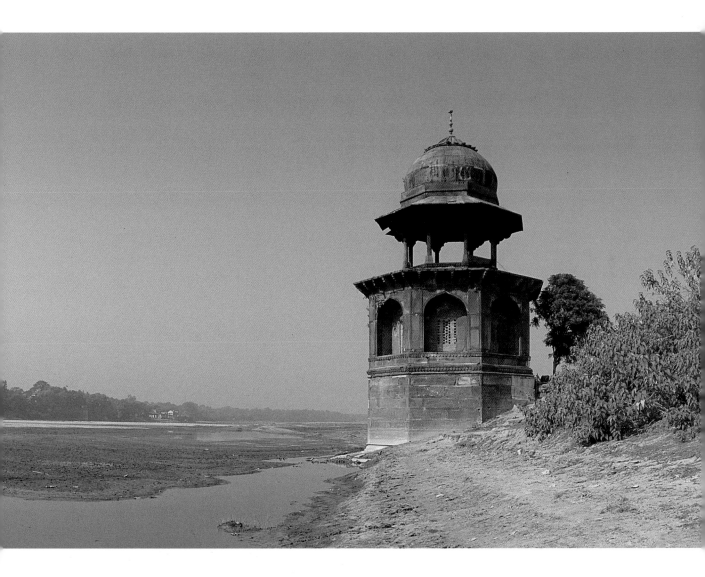

Published by the ARTHUR M. SACKLER GALLERY, *Smithsonian Institution, Washington, D.C.,*

*and the* UNIVERSITY OF WASHINGTON PRESS, *Seattle and London*

Published as part of the Asian Art & Culture series by the
Arthur M. Sackler Gallery, Smithsonian Institution,
Washington, D.C. in association with the
University of Washington Press, Seattle and London

This publication was supported in part by the
Donald E. Ellegood International Publications Endowment.

Editor: Karen Sagstetter
Designer: Carol Beehler
Typeset in Monotype Centaur
by General Typographers, Inc., Washington, D.C.
Printed in Hong Kong

Cover: A lily from the *iwan,* or entrance, leading to the main
funerary chamber of the Taj Mahal, 1999.
Photograph by Neil Greentree
Back cover: The Moonlight Garden, or Mahtab Bagh, seen from
across the river at the Taj Mahal, 1999.
Photograph by Neil Greentree
Frontispiece: The Taj Mahal seen across the Yamuna River from
the southeast tower of the Moonlight Garden, or Mahtab Bagh,
1999. Photograph by Neil Greentree
Chapter opening illustrations: Details from the interior of the
funerary chamber of the Taj Mahal showing the white marble
inlaid with *pietre dure,* in floral motifs with semiprecious stones,
1999. Photographs by Neil Greentree
All photographs taken by Neil Greentree are copyright © 2000,
Arthur M. Sackler Gallery and Freer Gallery of Art, Smithsonian
Institution
Figures pp. 63, 65, 67, 70, and map of India, p. 94 by Gene Thorp

Library of Congress Cataloging in Publication Data
The moonlight garden: new discoveries at the Taj Mahal/edited
by Elizabeth B. Moynihan.
p.   cm.   — (Asian art & culture)
Includes bibliographical references and index.
ISBN 0-295-98034-6 (alk. paper)
1. Mahtab Bagh (Agra, India). 2. Gardens, Mogul—India—Agra.
3. Taj Mahal (Agra, India). 4. Agra (India)—Antiquities.
I. Moynihan, Elizabeth B. II. Asian art & culture (unnumbered)
DS486.A3 M66 2000
954'.2—dc21                                   00-056352

Smithsonian
*Freer Gallery of Art and
Arthur M. Sackler Gallery*

# Contents

# INTRODUCTION

*Milo Cleveland Beach*

To those visitors looking across the Yamuna River from the platform of the Taj Mahal, the land has long seemed little more than farmers' fields and barren ground. Historical references, however, as well as paintings from the time of Shahjahan (reigned 1628–58) reveal that it was once densely covered by rectangular walled enclosures and lush vegetation. The Mughal emperor Babur (reigned 1526–30) built the first gardens here as a way of evoking the characteristic delights of the homeland he had abandoned when he moved from Central Asia into India in 1526. Eventually, as the Mughal Empire grew more powerful, the riverbank became lined with gardens belonging not only to the imperial family but also to important nobles. Farther to the west, across from the great Red Fort, extensive (but still very fragmentary) remains of those gardens can be seen; looking north from the Taj, however, nothing is visible but portions of a garden wall along the river frontage and abandoned fields beyond.

In early January 1995, the U.S. National Park Service concluded a seven-year study of Agra (the Agra Heritage Project) by convening a joint blue-ribbon panel for which former Ambassador Abid Hussain and Elizabeth B. Moynihan served as co-chairs.[1] The panel heard reports and commented on various aspects of the project, which was concerned with resource management and tourism related to Agra's role as a World Heritage Site. During the course of the meeting, the panel was taken to the banks of the Yamuna River directly opposite the Taj Mahal, where—despite the fact that access was very difficult—plans for new tourist facilities were being proposed.

The location provided a stunning and unusual view of the Taj. And during the previous year, preliminary to a proposal for its development, the Archaeological Survey of India had explored the site and uncovered enough remains to confirm seventeenth-century references to a large garden located there during Shahjahan's lifetime. A letter to the emperor from his son Prince Aurangzeb, dated 1652 (see p. 28), for example, states that the garden had recently been flooded and was in need of restoration. (This must have been a continuing problem, for the land was low, and the garden was placed at a bend in the Yamuna, which regularly overflowed its banks during monsoon floods.) The visit also revealed that the width of the garden and its alignment were exactly those of the gardens at the Taj. This finding suggested that the garden—known as the Mahtab Bagh, or "Moonlight Garden"—might have been more significant than anyone realized.

Following the conclusion of the panel's meeting, Elizabeth Moynihan and I returned to explore the site more thoroughly, and we were joined by P. B. S. Sengar, the superintending archaeologist for the Archaeological Survey of India. Mrs. Moynihan's studies of Mughal gardens, and her re-identification of the great garden built by Babur south of Agra at Dholpur, had brought increased international attention to the study of Mughal garden sites, while the Arthur M. Sackler Gallery had recently completed a multiyear project in Pakistan documenting garden sites near Lahore. I was myself absorbed at that time with study and publication of the great *Padshahnama* manuscript—the official illustrated life of Shahjahan—in the Royal Library, Windsor Castle, preparatory to its exhibition in Washington, D.C., and elsewhere. Our eagerness to become involved with the study of the Mahtab Bagh was intense, since it promised to provide important new information for existing research projects. This interest was met with great generosity by the Archaeological Survey, and an international, interdisciplinary project to document the surface remains of the site was quickly established under sponsorship of the Arthur M. Sackler Gallery in cooperation with the Archaeological Survey. Its objectives were to characterize the surface of the site; to record the form of standing and ruined structures; to plan limited test excavations to investigate the nature of subsurface remains; to suggest further excavation and conservation strategies; and to prepare a report on the site and its documentation. This volume is that report.

Elizabeth Moynihan devised and directed this project for the Sackler Gallery. Among the meaningful finds described in her leading essay here is that in plan, proportion, and directional alignment, the Mahtab Bagh extends the design of the gardens at the Taj Mahal. While this relationship was forgotten over time, almost certainly due to repeated flooding of the site, visitors in the seventeenth century would certainly have been aware of the original scheme. Her essay, exploring the implications of this continuity, presents an expansive new interpretation of one of the most famous buildings in the world and lays to rest those early reports by European travelers that Shahjahan planned to build a replica of the Taj in black marble on the site for his own tomb. Furthermore, Mrs. Moynihan offers a possible source for those rumors.

David L. Lentz is the first paleoethnobotanist to work at a Mughal garden site. His contribution to this publication is based on an extensive analysis of soil samples—and thus on solid fact. It reveals the overwhelming presence within the Mahtab Bagh of plants indigenous to India rather than those plants described in the poetry and beloved in the memory of the immigrant Mughals. While they could impose new architectural forms on the lands they conquered, the vegetation they planted had to survive the heat of Agra.

James L. Wescoat Jr. brings his extensive knowledge of water systems in South Asia and elsewhere to his discussion of the waterworks at the Mahtab Bagh. For the first time we are given information about the amounts of water needed to maintain garden sites, how

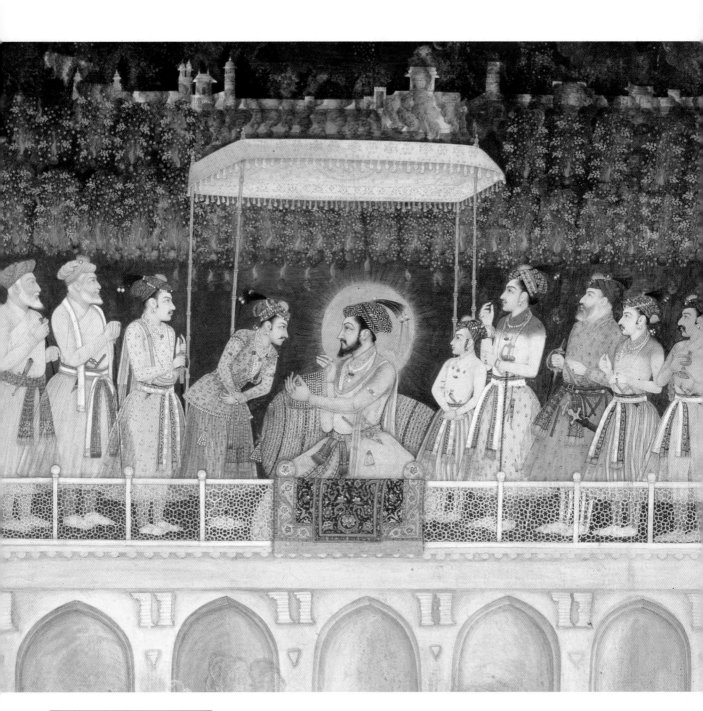

Detail, *Shahjahan Honoring Prince Dara-Shikoh at His Wedding*, painted by Bulaqi, India, ca. 1635. Opaque watercolor and gold on paper, folio 124b, 38.8 x 24.1 cm. From the *Padshahnama, Chronicle of the King of the World*. Given by the Nawab of Oudh to George III in 1799. The Royal Collection © 2000, Her Majesty Queen Elizabeth II. At top left is a walled garden on the riverbank. Pleasure gardens extended from the Mahtab Bagh for several kilometers west along the Yamuna River.

water was distributed, and the impact of this usage on the surrounding countryside. Perhaps his most intriguing insights concern how the use of water affected the experience of the garden for its visitors.

What was visible at the Mahtab Bagh is also the subject of the research by John M. Fritz and George Michell. Their essay carefully describes what remains and what we can presume to have once existed. The large octagonal pool on the riverfront terrace emerges as central to the identity and originality of the garden, just as it was central to the experience of viewing the Taj Mahal from this extraordinary site.

The rich historical materials and new interpretations offered by these authors are evidence that even the most familiar monuments retain the ability to surprise us. The site of the Taj Mahal is one of the most compelling in the world, and we hope that these studies will contribute to making a new generation aware of its power and beauty. ▨

NOTE

1. Other Indian members of the panel were Mrs. Pupul Jayakar, Dr. M. C. Joshi, and Dr. Kapila Vatsyayan, while American members were Ambassador Harry C. Barnes, Dr. John C. Cool, and Milo C. Beach.

# ACKNOWLEDGMENTS

In his introduction, Milo Cleveland Beach describes the genesis in January 1995 of our joint Indo-U.S. project to document the Mahtab Bagh. Two months later at what was regrettably the last meeting of the Indo-U.S. Sub-Commission on Education and Culture I presented a proposal for the project to Secretary of Culture B. P. Singh, and to Director General of the Archaeological Survey of India (ASI), Mrs. Achala Moulick, who endorsed the project.

Because the Agra Heritage Project included plans to develop the Mahtab Bagh, there was some urgency in undertaking the documentation as soon as possible. The permission process was expedited through the extraordinary effort of Saima S. Khan, in the Science Office of the U.S. Embassy, and thanks to R. C. Aggarwal, director of monuments, ASI, we were able to begin fieldwork in October 1996.

Key to this effort was help given by the U.S. Embassy Counselor for Scientific and Technological Affairs, Paul C. Maxwell, who set aside funds to help support the fieldwork. Additional funds for transportation and equipment were provided by a group of generous friends, Shelby White, Eileen P. Blumenthal, Nina Rosenwald, and Susan H. Jones. We were pleased that some of them could join us at the Mahtab Bagh during our fieldwork, but disappointed that Francine Berkowitz, director of the Office of International Relations, Smithsonian Institution, who has helped individual members of the project team often over the years, was unable to visit the Mahtab Bagh site.

Gregory Long, president of the New York Botanical Garden, and Brian Boom, vice president for science, were most generous in encouraging David L. Lentz, director, Graduate Studies Program, as a member of the interdisciplinary team, and have supported his continued participation. The University of Colorado has been similarly generous, and the scientific depth of the team was strengthened when James L. Wescoat Jr. joined us for additional fieldwork in 1997.

P. B. S. Sengar, superintending archaeologist of the Agra Circle of the ASI, who had directed the original excavations of the Mahtab Bagh in 1994 and 1995, assigned archaeologists G. N. Shrivatsa and O. D. Shukla to the project, while remaining an active guide and participant himself. Dr. Sengar's involvement made the joint project possible; he was available each time the team members were at the Mahtab Bagh and provided necessary assistance. We are grateful that his successor as director of the Agra Circle, D. V. Sharma, has taken an interest. We wish to thank all other officers of the ASI with whom we have worked, especially Additional Director General S. B. Mathur.

David Lentz enjoyed the hospitality of colleagues at the University of Delhi and expresses his particular thanks to Anupam Joshi and C. R. Babu for their help with field collections. We wish to join him in thanks to his colleagues at the New York Botanical Garden, including David Burney for completing the pollen extractions, Susan Fraser for her diligent search of the LuEsther T. Mertz Library for botanical illustrations, Muriel Weinerman for photographing the library material, and Marlene Bellengi for her assistance and support. The collection of archaeobotanical material was made possible by the team of ASI employees assigned to clear brush, dig pits, and assist Dr. Lentz, and we are most grateful for their help.

Jim Wescoat reports he could not have completed his study of the water system without the cooperation of Babaji, who allowed him to clamber over the cistern near his ashram at the southeast corner of the garden. We are grateful to the five workers of the ASI who cleaned out fountain pits in blistering conditions of midsummer for Wescoat's inspection—Dayal Krishna, Bahadur, Rajinder, Brahmajit, Dev Kumar and to Vijay of Tajganj, for faithfully rowing him and Dr. Lentz across the Yamuna to and from the garden.

George Michell was assisted in measuring the garden by John-Henry Rice and Khandu Deokar; the latter was responsible for preparing architectural plans, elevations, and details. Topographic & Engineering Surveys of Bangalore produced a 1:500 map of the site. Surveying the garden was difficult because of the four-meter-tall *phuse* grass that covered the site. The surveyors completed the survey after the grass was cut. However, soon after, the ASI had the accumulated silt, between two and three meters deep, removed down to the Mughal level and deposited in the riverbed along the front wall of the garden. This prevented examination of the riverbed for traces of the landing, or investigation for remains of the access to the garden from the river.

Unfortunately, members of the original team, Thomas Kent Hinckley and James Walker of Brigham Young University, were unable to complete the low altitude aerial photography due to the crash of their radio-controlled model airplane. They were being assisted by ASI photographers Mr. Kaw, Mr. Nauriyal, R. K. Verma, and Sovan Chatterjee, who had been trained in the technique in the United States on a grant from the Indo-U.S. Sub-Commission on Education and Culture, and though the plane was recovered, the failure of the flight was a disappointment to all team members. We sincerely appreciated the cooperation of the Indian Air Ministry in arranging the radio frequency required for the plane and the radio-controlled camera and for sending an observer to assist.

We were warmly welcomed to India at the Imperial Hotel in New Delhi, and in Agra, Rajeev Lall made the garden wing of Laurie's available to us in the pleasant weather of October. Camellia Panjabi made it possible for the team to conduct fieldwork in midsummer by arranging housing for them at the Taj View Hotel for which we are most grateful. For our ground transportation and general assistance in Agra we are grateful to Naresh

Khetharpal of Marvel Tours; he was reliable, indeed indispensable. Pradeep Mehendiratta, director general and vice president of the American Institute of Indian Studies, generously made the facilities of the institute available to the team. We welcomed the interest and support of this joint project by Naresh Chandra, the Ambassador of India to the U.S.; though he offered his assistance, which we appreciated, happily it was never required.

For advice and encouragement over the years, I am grateful to M. C. Joshi, and to C. S. H. Jhabvala, who first taught me about Mughal architecture and who graciously cast his critical eye on the essays in this volume. Amita Baig was consistently helpful and energetic in keeping the joint team members aware of developments and in communication. I am personally grateful for the interest and encouragement of Bimla Nanda Bissell, Mira Singh, and Rajeev Sethi, whose friendship over thirty years has made every working day in India a joy.

The Publications Department of the Freer and Sackler galleries has been superbly efficient and imaginative. Karen Sagstetter has a gifted editor's ear and Carol Beehler has a gifted designer's eye, and we are fortunate they collaborated on this book. Jacqueline Bullock provided thoughtful assistance at every stage of the publishing process; Ann Hofstra Grogg and Michelle Smith provided editorial expertise. Neil Greentree's magnificent photographs are a great contribution, and we are grateful that he was in India and could join us on our last field trip. We were very fortunate that Wheeler Thackston retranslated Aurangzeb's letter to Shahjahan, and we thank Massumeh Farhad, associate curator of Islamic Art of the Freer and Sackler galleries, for translating the Persian notations on the plan of the Taj Mahal complex.

This has been a hugely successful collaborative effort, with each member of the team bringing something different to the project. I am grateful to all the members for their generosity in making themselves available for the field trips and consultations and for their final reports. It has been a privilege to work with them.

Finally, but most important, this project could never have been undertaken without the vision and support of Milo Beach. We are indebted to him for sharing his knowledge and perceptiveness about Mughal culture; it has been a pleasurable learning experience for all of us. ▨

*Elizabeth B. Moynihan*

*For Ajai Shankar*

Our deepest thanks for the completion of this project are due to
Ajai Shankar, Director General of the Archaeological Survey of India
from 1996 until his tragic death in an accident in February 2000. Among
his first decisions on his appointment was the approval of our joint project
to document the Mahtab Bagh, and he remained interested and involved throughout
our fieldwork. In our last meeting with him, in October 1999, he discussed the
Indian contribution to this volume; he proposed an outline of future
plans being developed by the ASI for the Mahtab Bagh.
Without this contribution, this volume is sadly incomplete.
For the project team his death was also
a personal loss.

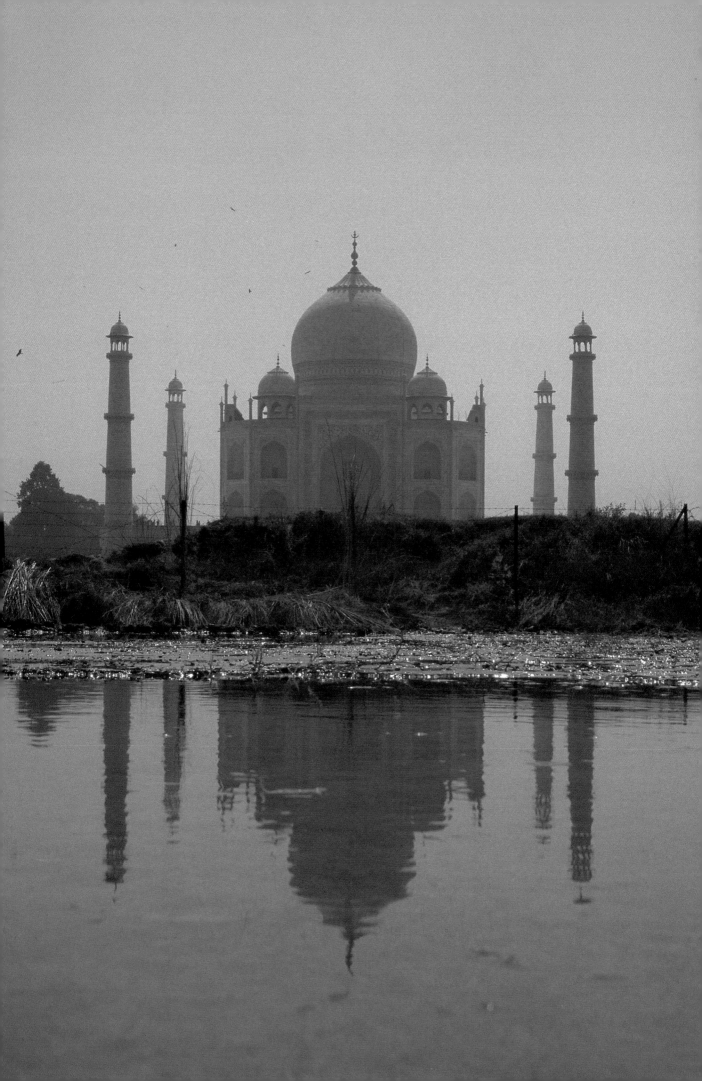

# Reflections of Paradise

*Elizabeth B. Moynihan*

F ROM ITS SOURCE in a glacier lake (at 4,421
meters) in the western Himalayas, the Yamuna River emerges through steam rising from hot
springs, drops through the foothills, and flows south past Delhi. Turning eastward above
Agra it slows, winding across the alluvial plain to Allahabad, ending in what Hindus regard
as a mystical union with the Ganges. At the confluence of these two holy rivers, pilgrims cel-
ebrate the *kumbha mela*, one of the largest ritual gatherings in India, but many hallowed sites
dot its shores along a 1,528 kilometer course. In the sacred geography of India, life-giving
rivers are represented by goddesses and command a special reverence for their purifying
powers: the goddess Yamuna is venerated as the daughter of Surya, the solar deity of the
Vedic period (1200−100 B.C.).

## BABUR'S GARDENS
Along the Yamuna's banks in the sixteenth century there were great stretches of thick forests
and tall grassland, home to numbers of wild beasts unfamiliar to Zahiruddin Muhammad
Babur (1483−1530), the Central Asian prince who founded the Mughal dynasty (1526−1858).
To commemorate his victory at Panipat over a confederation of feudal, mainly Muslim
rulers of northern Hindustan led by the Lodi sultan, Babur ordered the construction of a
mosque surrounded by large gardens. The next day, April 21, 1526, he started south along the
Yamuna for Agra.

Though no longer the seat of government, Delhi was still the strategically important
gateway to the fertile Gangetic plain. The area to the east, including Agra, falls within the
limits of Vraja, the sacred pasture, an ancient land that saw the development of arts and lan-
guages like Sanskrit and Prakrit. Raids by zealous iconoclastic Muslims began with some

frequency in the tenth century, and by the twelfth the land between the rivers, the Yamuna-Ganges Doab, was conquered and saw the rise and fall of five successive Muslim dynasties and their capitals.

On arriving in Delhi, Babur first made a circuit of the tomb of the Sufi saint, Shaykh Nizamuddin Awliya (died 1325), presaging the association of his descendants, particularly Akbar (1542–1605), with Chisti *dargah*s, shrines. Following four days of sightseeing, and nights celebrating with his friends, the significant event for which he was waiting took place: the *khutba*—the Friday prayer—was read in his name in the congregational mosque, a public acknowledgment of him as the new ruler of Hindustan. The following morning, as the army broke camp for the march to Agra, Babur made a quick return visit to Tughluqabad. Clearly, the fortress of massive stones looming above the fortified white-domed tomb of the first Tughluq sultan had made an impression on him. The citadel had remained desolate since sacked in 1398 by Timur (1335–1405), known in the West as Tamerlane. As the last ruling Timurid, Babur had justified the expedition into Hindustan as his right; he was reclaiming his ancestor's former territory.

It was a compelling moment in a life of startling contrasts. At twelve Babur had inherited the throne of Ferghana, a minor province in Central Asia, but by eighteen had lost it and went on to win and lose Samarkand twice. Even when he was throneless and poor, in an age of constantly shifting loyalties, Babur's reputation as a fair and fearless soldier and charismatic leader drew men to him. Thus he acquired a sufficient following to take the kingdom of Kabul without a struggle in 1504. In the intervening years he made four excursions into Hindustan, which helped prepare him for his 1526 victory.

The mountain men in the Mughal army found the heat of the jungle oppressive; in the open areas they endured unrelenting sun and the sudden blinding dust storms of the pre-monsoon season. Along the Yamuna, nearing Agra, they passed through the legendary landscape of Krishna's birth and childhood that had once been a great center of Buddhism as well. Agra was little more than a rebellious village in 1504 when the Lodi sultan built a mud-brick fort at a wide bend in the river and shifted his government from Delhi. Babur found Agra deserted when he entered the city; there was no food for the army, no fodder for the horses. The people had fled in fear of him—this Chaghatay Turk, a Timurid who was also a descendant of Chingiz Khan.

Page 14: The Taj Mahal reflected in the octagonal pool of the Mahtab Bagh, October 1999. The image indicates careful planning. It is a remarkable engineering achievement, as the tomb would seem to be out of reflective range. Photograph by Neil Greentree

Babur's own words tell us of this crisis. It was his lifelong habit to keep a journal recording events and impressions of people, and during his years in India he assembled his notes and produced a remarkable autobiography that was venerated by his descendants. But the *Baburnama* was not a mere attempt to legitimize and glorify a dynasty as was the usual historiography of the time; it reveals an educated, culti-

vated person with a disarmingly direct style. "The year was a very hot one; violent pestilential winds struck people down in heaps together; masses began to die off. On these accounts the greater part of the begs [officers] and best braves became unwilling to stay in Hindustan. . . . When I knew of this unsteadiness amongst [my] people, I summoned all the begs and took counsel. . . . I made them, willy-nilly, quit their fears."[1]

Fascinated by this new country, Babur recorded precise, vivid descriptions of the animals, birds, and plants of his new domain, but he was disappointed with the flat terrain around Agra. He longed for the hills of Kabul, where he built terraced gardens with panoramic views of the surrounding countryside. Essentially a soldier whose life was spent riding and camping with his men, Babur preferred sleeping beneath an awning in a garden rather than in the chambers of a fortress, so in Agra he searched for an adequate site for a large *bagh*, or garden, where he could live.

The circumstances confronting Babur prevented his following the traditional Timurid practice of building a large-scale architectural project to assert political domination by artistic means. His resources, personnel, and finances were stretched thin over a wide area in a dangerously volatile political-military situation. His innovative solution was prompted by his interest in the natural environment and gardens; he used the undeveloped bank of the Yamuna as the setting for a series of large *charbagh*s (fourfold gardens) enclosed by high walls and patterned on the Persian paradise garden, imported into Central Asia by Timur. Instead of palaces, he built several extensive gardens and instructed his nobles to do the same on tracts allotted to them along the Yamuna. In Kabul, springs were the source of the gravity-fed water systems supplying the narrow channels he preferred as the main axes in his gardens, but his Yamuna gardens flourished with wells.[2]

Although palace gardens existed in pre-Mughal Islamic India, there was nothing comparable to the scope of this verdant development along the sandy margin of the Yamuna. As Babur recounts: "Khalifa also and Shaikh Zain, Yunas-i-ali and whoever got land on that other bank of the river laid out regular and orderly gardens with tanks, made running-waters also by setting up wheels like those in Dipalpur and Lahor. The people of Hind who had never seen grounds planned so symmetrically and thus laid out, called this side of the Jun where [our] residences were, Kabul."[3] In the inevitable style of empires where the ruler is the arbiter of fashion, gardens soon lined both sides of the Yamuna; the fort and its neighborhood were surrounded by gardens evoking the manner in which Timur surrounded Samarkand with large, walled gardens. A detailed description of those gardens as seen in 1403 by Ruy Gonzalez de Clavijo, the emissary of the king of Spain to Timur, has survived.[4] In a monograph on fifteenth-century Timurid gardens, the Russian scholar Galina Pugachenkova concluded they "had a strictly established plan based on a system of geometrically structured axes (two or more) issuing from a single point. . . . Architecture, vegeta-

Detail, the young Babur in a battle. Folio
from the *Babur Nama*, India, ca. 1590.
Opaque watercolor and gold on paper.
Private collection. Photograph by
Milo C. Beach

tion, and water supplement each other harmoniously, combining gar-
den, pool, palace and pavilions into one organic whole."[5]

Babur knew the splendid Timurid cities of Samarkand and Herat,
where he lived in a great garden for a time and took pride in the
dynasty's history and achievements. Timur's political domination of
much of the world was achieved by his military prowess, aided by his reputation for being
ruthless and his terrifying, swift approach. Defeat was deemed inevitable and resistance
futile, so often cities surrendered immediately. Although they paid him handsomely, still he
carried off their skilled artisans to build his capital, Samarkand. Timurid art was a synthesis
of the aesthetics of the captive artists and craftsmen and the Persianate culture of the
Central Asian steppes.[6]

Conscious of his cultural legacy and the political advantages that might accrue, Babur
integrated local traditions into his building projects by allowing native craftsmen to use
Indian themes. An example is his Lotus Garden at Dholpur,[7] where the theme—the life of
the lotus—introduced in a series of rock-cut pools the decorative element so favored by his
descendants. He also required the use of new material rather than elements taken from tem-
ples, a practice common in pre-Mughal Islamic construction.

Babur officially ordered the construction of walled "symmetrical" gardens throughout
his new domain: "Urged on by the usages, consequent upon conquests, the king issued his
commands, and conveyed that, in shortest time, in all great cities, gardens and orchards be

laid out."[8] They achieved his political purpose by representing the imperial presence. They were used by later Mughal rulers who, proud of their seminomadic roots, constantly moved about and preferred the gardens as "a halting place" whenever possible.

In the century preceding Babur's conquest of Hindustan, Timurid monuments—usually mosques, tombs, madrasas, and minarets—sheathed in brilliant glazed tile, were religious symbols even as they signified dynastic power. Babur used the landscape to make a political statement but without overt religious symbolism, although within the walls, often three meters high, garden architecture might include a mosque. Consistent with his personal style, this practice differed from the Timurid pattern of large architectural complexes, followed in later decades by the creation of lavish garden suburbs.[9] While Babur's gardens were secular in character, some Kashmiri gardens of his descendants assumed a mystical character. As Annemarie Schimmel has explained, "The octagonal pavilions erected in some of the Mughal gardens as similitudes of the cool pavilions described in Sura 55 are certainly connected with this idea of the paradisiacal number eight as is the idea of laying out gardens in eight or—to surpass even Paradise—in nine terraces, connected by water courses."[10]

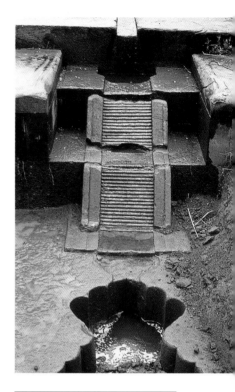

Water chute between two rock-cut lotus pools on the main terrace, Lotus Garden at Dholpur, 1978. Photograph by Elizabeth B. Moynihan

It is not possible to recreate the original layout of Babur's Yamuna gardens, but we have his account of building the first one.

> The beginning was made with the large well from which water comes for the Hotbath, and also with the piece of ground where the tamarind-trees and the octagonal tank now are. After that came the large tank with its enclosure; after that the tank and *talar* in front of the outer residence; after that the private house with its garden and various dwellings; after that the Hot bath. Then in that charmless and disorderly Hind, plots of garden were seen laid out with order and symmetry, with suitable borders and parterres in every corner, and in every border rose and narcissus in perfect arrangement.[11]

The transformation of the Yamuna's banks required considerable engineering skill and manpower. Each garden required tons of rock and earth, brick and stone for the construction of terraces and high retaining walls, sometimes three meters thick, with landing platforms strong enough to withstand the river in spate. There were wells, or *burjs*—towers built at the corners—an imposing entrance gate on the river, raised paths, pavilions, and stone platforms throughout the garden. Long sections of Mughal-era walls remain along the river,

although most traces of the gardens have vanished and the land has been altered for industrial or residential use. Behind these massive walls, beneath the terraces, the Mughals often constructed domed chambers; here, in at least one of his gardens, Babur constructed baths. "Three things oppressed us in Hindustan, its heat, its violent winds, its dust. Against all three the Bath is a protection, for in it, what is known of dust and wind? And in the heats it is so chilly that one is almost cold."[12]

Babur lived in his gardens composing music and poetry and entertaining friends, using the gardens as staging areas for military campaigns. With the amenities of a palace, he held formal events such as diplomatic receptions. Later, Mughals' enjoyment of the Yamuna gardens continued but was not reverential; as with palaces, their appearance and use changed over time according to the interests and taste of the rulers. Babur's son Humayun (reigned 1530–40, 1555–56) apparently lived in the fort but frequently entertained or held ceremonial functions in the gardens. There are descriptions of Mughal feasts in which the terraces "as well as the boats along the Jumna, were illuminated with lamps."[13] For such festivities, silken awnings, rich carpets, bolsters, cushions, and elegant hangings decorated the pavilions and platforms; musicians, acrobats, singers, and dancers entertained, followed by a great display of fireworks.

The best-preserved Yamuna garden, currently known as the Ram Bagh, with riverside terraces, baths, stables, water devices, and wells, gives a sense of the scale of imperial *baghs*. In his *Memoirs*, the Emperor Jahangir (reigned 1605–27), Babur's great-grandson, says his father Akbar planted pineapples "found in the Franks' ports. It is extremely good-smelling and tasting. Several thousand are produced every year in the Gulafshan Garden in Agra."[14] All the Mughals had a fondness for fruit and planted groves of fruit trees in the plots. Jahangir renamed the garden the Bagh-i Nurafshan when he turned a large area of Agra, including the Gulafshan, over to his queen, Nurjahan (1577–1645), who built the surviving pavilions. A woman of great taste and talent, Nurjahan was involved in planning many of Jahangir's gardens.

Gardens with a funerary association were more likely to survive, and it was long thought that after Babur's death in 1530 he was buried in the Gulafshan for several years before being moved to his favorite garden in Kabul. Some authorities claim another of his Yamuna gardens, the Charbagh, was his burial place. At the time of Babur's death, Humayun had completed construction of a mosque adjacent to his father's Charbagh; Timurid gardens often melded with the precincts of mosques that included cemeteries. Near Humayun's mosque there are gravestones inscribed with the names of Babur's learned friends from Kabul who built Yamuna gardens at his direction.[15] It does seem likely that Babur's companions would have been buried in proximity to his grave. Abu'l-Fazl Allami, Akbar's great friend and the chronicler of his reign, illustrated the open nature of early Mughal society

and the access highly placed nobles had to imperial gardens when he wrote of Babur's Charbagh, "It was the birth-place of the writer of this work, and the last resting-place of his grandfather and his elder brother."[16]

Little is known of the Yamuna gardens during the fifteen-year hiatus in Mughal rule following Humayun's overthrow. A promising youth who grew obsessively superstitious and eccentric, Humayun became dependent on opium. As a ruler he was inept and exhibited terrible judgment, frustrating his ambitious brothers. Sher Shah Sur, a feudal chieftain, raised a following, led an insurgency, and drove Humayun out of Hindustan. He sought refuge in Iran and with Iranian help eventually recaptured Kabul following fratricidal battles. Eventually Humayun regained Hindustan but died within the year, leaving his son, fourteen-year-old Akbar, emperor of a very shaky realm. At the time Akbar was on a military campaign in the Punjab, where he was crowned on February 14, 1556, the seventy-third anniversary of his grandfather Babur's birth.

## LATER EMPERORS

From the beginning of Akbar's reign (1556–1605) through 150 years of powerful Mughal rule, the emperors continued to emphasize their Timurid lineage and glorify the founders, Timur and Babur. Like Babur a fearless and decisive military leader, Akbar found inspiration in his grandfather's tolerance and curiosity. Babur's intellectual pursuits were literary; Akbar's intellectual interests were philosophical, the most controversial being his study of known religions. Though Babur had a rare understanding of men and events, he could seldom control them, whereas Akbar ruled with absolute authority for forty-nine years. He consolidated the empire, and with political stability came wealth and increased power. In the arts he created the famous Mughal *kitabkhana*, or library and painting workshop. His architectural endeavors focused on building magnificent stone forts at strategic locations as he expanded the empire, and although he showed limited interest in gardens, he is credited with the most important innovation in Mughal gardens.

Built at Akbar's direction on the banks of the Yamuna at Delhi, the tomb of his father Humayun was set in the center of a large *charbagh*, the earthly reflection of the Islamic paradise and the prototype of future Mughal tombs. The Yamuna has wandered from its former banks, but the garden and tomb survive. A stone perimeter wall encloses an area of approximately twelve hectares.[17] The quadripartite layout of the garden on a single plane is divided by wide pathways with each quarter subdivided into eight plots. Centered in the garden paths, the narrow watercourses represent *nahr*, the Four Rivers of Paradise, as they converge at the plinth bearing the tomb; thus the red sandstone tomb, with its graceful white marble dome, rises symbolically as the sacred mount above the crossing of the Four Rivers.

Humayun's tomb is perhaps the first real Mughal *charbagh* we can actually trace. Shortly after taking Kabul, Babur wrote: "I laid out the Four Gardens, known as the Bagh-I-Wafa. . . In the middle of it, a one-mill stream flows constantly past the little hill on which are the four garden plots."[18] He made other references to "a *charbagh*," but it is not clear he divided his gardens in the classic *charbagh* pattern, nor were all his pre-Indian gardens walled. We know that terraces of equal size with straight watercourses characterized his gardens. This arrangement and his genius for siting gardens were still apparent as late as 1978 in his garden on a mountain spur at Istalif, Afghanistan. We also know he experimented, introducing new plants and unusual trees. It is probable that Babur's orderly gardens had a lively ambience and a vitality the later gardens lacked.

Painting flourished under Akbar's son Jahangir, who had exquisite, detailed botanical studies painted to satisfy and inform his discriminating interest in plants. Particularly fond of Kashmir, he made several lengthy visits and created large, terraced gardens on the slopes overlooking Dal Lake. During his reign the first European traders traveled to Agra and wrote strikingly similar descriptions: "It lies in the form of a half-moon on the banks of the River Jemini. . . which is overhung by many very beautiful palaces belonging to the nobles of the empire. The prospect towards the river is most pleasant for about six coss [five kilometers] or more along its banks."[19]

## SHAHJAHAN

Though Jahangir wrote fondly of his father in his *Memoirs*, theirs was a troubled relationship and he was displaced in Akbar's affections by his own sons. Akbar enjoyed a particularly close relationship with Jahangir's third son Khurram, the future Shahjahan (1592–1666), who grew up in his household. At Khurram's birth Akbar had given the child to his own first and principal wife to raise. The childless, aging queen doted on the boy.

During Akbar's final illness, Khurram, then thirteen, refused to leave his dying grandfather, and so witnessed an attempted coup by nobles to put his seventeen-year-old brother Khusrau on the throne. However, Jahangir prevailed and imprisoned Khusrau, who later escaped, rebelled, and was captured and blinded. Poison ended his unhappy life while he was confined to the care of Khurram, by then known as Shahjahan. On the death of Jahangir,

*Jahangir and Khurram Feasted by Nurjahan,* India, ca. 1617. Opaque watercolor and gold on paper, 25.2 x 14.2 cm. Freer Gallery of Art, Smithsonian Institution, gift of Charles Lang Freer. The setting is thought to be Nurjahan's Nurafshan Garden, now known as the Ram Bagh, and illustrates how the Yamuna gardens were used.

Shahjahan (reigned 1628–58) secured the throne by the murder of his younger brother and other Timurid relatives. By his ruthless ambition he dishonored the Timurid code, which guaranteed the safety of young princes. Many years later, after a reign of thirty-one years, his health and control weakened with old age, Shahjahan watched his own sons destroy each other in a war of succession. The relationship between rulers, their heirs and brothers, was often convoluted; as a further

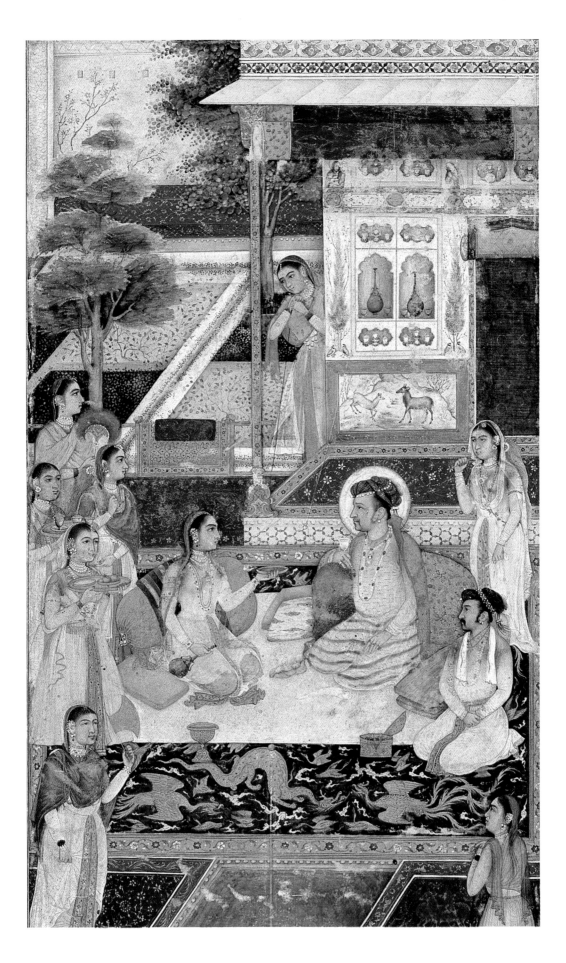

example, Shahjahan was deposed by his surviving son and successor, Aurangzeb (reigned 1658–1707), and confined for the last eight years of his life to the riverfront pavilions of the Red Fort looking east to the Taj Mahal.

The date chosen for Shahjahan's accession, February 14, 1628, the same date Akbar succeeded to the throne seventy-two years earlier, was the 145th anniversary of Babur's birth. Shahjahan assumed rule of a rich, stable empire with a highly centralized administration. A proven military leader and negotiator, he was an avid and knowledgeable collector of jewels and, as a prince, displayed a strong interest in architecture. As emperor he had the resources to build on the scale of the Central Asian Timurids, undertaking such massive projects as Shahjahanabad, a new capital on the Yamuna in Delhi, which, in Timurid fashion, served to signify foreign domination, for the Mughals remained essentially foreign.[20] The architect of his gardens is unknown, and Shahjahan is said to have assumed a major role in the design of his projects, approving every plan. The nobles, who regarded the stern emperor with some apprehension, were quick to follow his example, producing a building boom throughout the empire.[21] During this same period, a similar movement was taking place in France, where Cardinal Richelieu commissioned palaces as if he were a Mughal emperor, but the names of seventeenth-century French landscape architects are well known and those of Mughal architects are not. There is no evidence that the Mughals were influenced by contemporaneous Italian or French landscape designs. Their gardens retained a Timurid character even after foreign emissaries and traders were received at court and European influence could be detected in painting and architecture.[22]

In the beginning of Mughal rule, although it was said Timurid protocol was followed, court etiquette seems rather informal when compared to accounts of the complex ceremony of approach and ritual of submission required by Timur. However, under Shahjahan protocol became strict and formalized, reflecting his vision of kingship and his reserve and contributing to the aura surrounding the throne. As the architectural historian Ebba Koch has written, "The hierarchic relationship between Shahjahan and his subjects was confirmed and acted out symbolically in rigid court ceremonial, repeated daily, focusing on the Emperor."[23]

In portraits by his court painters, Shahjahan is always shown in profile surrounded by a nimbus suggesting a semidivine nature, the impression of the imperial ideal he encouraged.

Contemporary accounts describe Shahjahan as excessively cold and arrogant, counter to the commonly held impression of him today as a romantic who, engulfed by grief at the death of his beloved queen, built the Taj Mahal as her monument. Betrothed when she was fourteen, he fifteen, and married at twenty, Arjumand Bano Begum (1590–1629), known as Mumtaz Mahal, was reputed to be a Persian

Leaf from Jahangiri Album, 1595–97, by Fair Ali, artist calligrapher, and Salim Quli, artist, India. Opaque watercolor and gold on paper; image: 22.2 x 11.4 cm. The Nelson Atkins Museum of Art, Kansas City, Missouri; purchase: Nelson Trust. Photograph by Robert Newcombe © 1996. The figures in the right and bottom margins are *malis*, or gardeners, at work. Indian *malis* work much the same way today.

beauty, kindhearted and her husband's favorite companion. She died after delivering her fourteenth child in Burhanpur, where the court had moved following the emperor. Temporarily buried in a garden there, six months later her body was brought to Agra and kept near the construction site of the Taj until its completion and her final interment. Contemporary Mughal documents refer to the monument as the "Illuminated Tomb"; the term "Taj Mahal" is believed to derive from popular usage based on the queen's title, Mumtaz Mahal.

## THE TAJ MAHAL

Perhaps the most admired building in the world, the perfectly proportioned tomb makes a profound impression with its luminous white marble veneer, exceptionally sensitive to changing light. M. C. Joshi, former director general of the Archaeological Survey of India, has pointed out that the Taj represents the full development of several Mughal themes.[24] The architectural historian, R. Nath, described the Mughal engineers' skill in placing the weight-bearing piers of the structure on a series of deep wells compensating for the slope of the riverbank; these are still intact and effective, after some 350 years, in a significantly changed environment.[25]

The site chosen for the monument with a true north-south alignment was a garden Raja Jai Singh inherited from his grandfather Raja Man Singh, a friend of Akbar's and one of the first Rajput officials in the Mughal court. Known for their courage and code of chivalry, the Rajputs were one of the historic races of India. In a tradition observed by Timurids, that the dead not be buried in land obtained by force or violence, imperial land was exchanged for the Raja's garden.

Within its enclosure, the plan of the Taj differs from its predecessors due to the placement of the tomb on a high plinth at one end of the garden rather than in the center at the crossing of symbolic water channels. An interpretation of this plan by Wayne E. Begley theorizes that the Taj complex is an allegorical interpretation of the Day of Resurrection as revealed in the Koran. He compares the Taj enclosure to a thirteenth-century diagram of the Plain of Assembly by Ibn al-Arabi, whose mystical writings were influential on Indian Sufis.[26]

Shahjahan's preferred son and probable heir, Dara-Shikoh, was a student of Islamic mysticism whose teacher was influenced by al-Arabi's writings. Dara also studied Hindu mystical philosophy, translated the Upanishads, and became interested in Islamic pantheism. Shahjahan's favorite daughter, Jahanara (died 1681), his companion during his confinement, was deeply religious and a follower of the Chisti order of Sufis. His own relationship with several Sufi shaykhs was complex and well known, but Shahjahan's involvement in mysticism is not clear. Although the official history of his reign records details of daily court life,

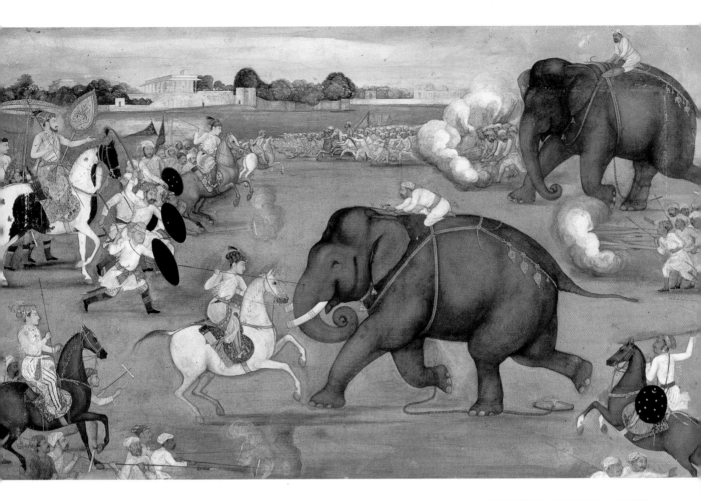

Shahjahan remains personally inaccessible: only his vanity and obsession with his own destiny are disclosed.

While the concept is a superb example of the paradise theme so beloved by the Mughals, clearly it was the intention of the architect of the Taj to intimidate the visitor. The verses inscribed on the white marble panels of the gate and the monument are among the most profound and awesome passages in the Koran. The grand scale, the imposing gate, the long approach to the monument, the wide paths, the size of the tomb and its unearthly appearance above the high plinth, the opalescent marble and jeweled decoration—all reinforce this perception.

Recently the number of visitors to the Taj has exceeded sixty thousand a week. Surging crowds threaten the structure itself and overrun the gardens, transforming the ambience and the intended experience. (One of the main environmental hazards to the Taj is moisture from the breath and bodies of the visitors who enter the tomb chamber.) For 350 years the formality of the garden layout and materials influenced visitors' behavior; they remained on the paths and were respectful. The Taj had, in fact, assumed the atmosphere of a shrine—

*Prince Aurangzeb Facing a Maddened Elephant Named Sudhakar*, painted by an unknown artist. India, ca. 1635. Opaque watercolor and gold on paper; folio 134a: 24.6 x 40.3 cm. From the *Padshahnama, Chronicle of the King of the World*. Given by the Nawab of Oudh to George III in 1799. The Royal Collection © 2000, Her Majesty Queen Elizabeth II. Note the walled riverfront garden in the background showing the landing, an airy pavilion, and dense foliage within.

# Letter from Aurangzeb to Shahjahan

dated 9 December 1652

*Translated by* Wheeler M. Thackston

After discharging the duties of sincerity and servitude, which insure everlasting felicity, this faithful servant humbly reports to the imperial presence that on Thursday, the third of Muharram [1063 = December 4, 1652], I entered Akbarabad [Agra] and went straight from the road to meet the Princess of the People of the World in the Jahanara Garden, and having enjoyed conversation with her in the delightful place, I went at the end of the day to quarters located in Mahabat Khan's garden. On Friday I went to circumambulate the Illuminated Tomb and obtained the blessings of visitation.

The buildings of these sacred precincts are as stable as they were when they were completed in the imperial presence. However, the dome over the blessed tomb leaks on the north side during the rainy season, and the four portals, most of the second-story alcoves, the four small domes, the four northern vestibules, and the vault of the seven-doored plinth[1] have gotten damp. The marble-covered roof of the large dome has leaked in two or three places during this season. It has been repaired, but we will have to wait and see what will happen next rainy season. The domes of the mosque and assembly chamber also leak during the rainy season. They have been repaired, but the builders suggest that if the facing of the second-story roof is opened, remortared, and tamped down [?] over the mortar to a depth of half a yard, the portals, alcoves, and small domes may be all right. They admit their inability to come up with a plan for the large dome. Blessed saint, extend your hand! Such magnificent buildings have been afflicted so by the evil eye! If a ray of imperial attention is cast to remedy the situation, it would be appropriate.

The Mahtab Garden was completely inundated, and therefore it has lost its charm, but soon it will regain its verdancy. The octagonal pool and the pavilion (*bangla*) around it are in splendid condition. It is surprising to hear that the waters of the Jumna have overflowed their banks because at present the river is moving back to its old course and is about to regain it.

On Saturday,[2] I had the Princess of the People of the World brought to my quarters, and the next day I went to see her and bid her farewell. On Monday the seventh I decamped from there, and today, which is the eighth of the month, I have reached the vicinity of Dholpur. God willing, as was previously reported, I will traverse the distances stage by stage without stopping anywhere until I reach the Deccan. May the world-illuminating sun of the caliphate always shine over the heads of the people of the world!

1. The "seven-doored plinth" must refer to one of the projections from the plinth in the middle of the north and south sides, both of which have seven arches in the marble facing.
2. Text has *sihshamba*, Tuesday, which must be a mistake. Aurangzeb arrived in Akbarabad on Thursday, visited the tomb on Friday, and departed on Monday. That leaves only Saturday and Sunday, which must be the days he saw Princess Jahanara.

despite the Islamic custom of simple burials based on the Prophet Muhammad's admonition against monumental tombs and veneration of the dead.

Early descriptions of the Taj garden are rare and its original planting scheme remains unknown. The French traveler François Bernier described the paved paths in July 1663 as "raised about eight French feet above the garden," and there were "several garden walks covered with trees and many parterres full of flowers."[27]

## THE MYTH OF THE BLACK TAJ

It is a commonly held notion, still touted by guides, that Shahjahan intended to build a second tomb of black marble opposite the Taj on the northern bank of the Yamuna in the Mahtab Bagh, or Moonlight Garden, and join them by a bridge. This reference to a second tomb evidently first surfaced in the account of visits to Agra in 1640 and 1665 by the French traveler Jean Baptiste Tavernier who claimed Shahjahan "had begun to build his own tomb on the other side of the river."[28]

Remains at the Mahtab Bagh indicate it was designed as a pleasure garden, not a tomb garden, and there never was a tomb there; at least twice since the 1970s archaeologists from the Archaeological Survey of India (ASI) have thoroughly examined the garden and found no evidence of the extensive foundation required to support such a structure. M. C. Joshi believes the original concept for the Taj complex may have included a tomb at the Mahtab Bagh but that the plan was abandoned by the time construction of the Taj began.

## THE TAJ MAHAL AND ITS MOONLIGHT GARDEN

The connection between the Taj Mahal and the Mahtab Bagh is borne out by early maps, which illustrate the plan of the Taj complex as a series of quadrants; a market and caravansary, the forecourt and subsidiary tombs facing the great gate, the formal garden facing the monument, the distance spanning the river from the north wall of the Taj enclosure to the wall of the Mahtab Bagh, and then the Moonlight Garden. Excavations by the Archaeological Survey of India in 1993–94 revealed the octagonal tank and in 1995–96 confirmed the existence of adjacent pavilions. But why would the Mahtab Bagh—part of the original Taj complex—be forgotten over the centuries, to be rediscovered only in the 1990s?

Although the Mughals had superior engineers and experience in moving and controlling water, from the terrace of the Taj it is obvious that the Mahtab Bagh and nearby gardens on the opposite lower bank where the Yamuna makes a deep loop were vulnerable to flood tides on the river. Even now, with the Yamuna depleted and degraded by industrial development and waste, the current is swift and can flood the Mahtab Bagh following strong monsoons. We have historical evidence that such an event took place shortly after it was built.

While constructing the Taj Mahal, completed in 1643, Shahjahan also undertook the creation of the new imperial city north of Delhi, which he named Shahjahanabad. In 1648 he moved into his marble apartments in the Red Fort there and did not return to Agra for some years. In December 1652, passing through Agra on a military mission for his father, Prince Aurangzeb visited his mother's tomb. After conferring with the architects about damage caused by recent rains, he wrote to his father suggesting repairs.

In his letter describing the leaks at the Taj, he goes on to say: "The Mahtab Garden was completely inundated, and therefore it has lost its charm, but soon it will regain its verdancy. The octagonal pool and the pavilion *(bangla)* around it are in splendid condition. It is surprising to hear that the waters of the Jumna have overflowed their banks because at present the river is moving back to its old course and is about to regain it" (see "Letter from Aurangzeb to Shahjahan," p. 28).

Aurangzeb's letter makes the definite link between the Taj and the Mahtab Bagh. The scarcity of later literary references and the existing physical evidence found during excavations of the site in the 1990s suggest that the Mahtab Bagh was all but abandoned after flooding, perhaps as early as the seventeenth century. During the British era the garden was used as an elegant camping grounds, and early ASI reports contain references to garden pavilions, but knowledge of the spectacular octagonal pool on the riverside terrace was lost, buried under two or three meters of silt, until 1993. Through the years the garden has been subjected to continuous pilferage; almost all of the sandstone cladding and architectural elements have been removed, and there has been serious brick robbing of the foundations and extensive mining of the garden plots along the riverfront wall (see "Archaeology of the Garden").

However, enough remains to allow for a plan to be drawn. From the surviving south-eastern corner tower, the exposed brick wall parallels that of the Taj enclosure on the opposite bank and their measurements correspond. There were extensive and sophisticated water works to supply the pools, fountains, and water channels (see "Waterworks and Landscape Design"). The marble fountains, the lotus pool, the central tank, and the sandstone columns complete with bases and the cusped arches they supported are those found within the Taj enclosure, and there are features similar to those found in Shahjahan's Shalimar Garden in Lahore.

Even in its current state the character of the Mahtab Bagh is clear: it was a sumptuous pleasure garden, vastly different from the garden in the Taj enclosure. This suggests that Shahjahan built the Mahtab Bagh, his Moonlight Garden, as a continuation of a narrative sequence—his "Garden of Delight," where the promised rewards of paradise could be enjoyed, complementing and thereby reaffirming the somber character of the garden within the Taj enclosure.

Moonlight gardens were a tradition enjoyed by Indians before the Mughals; after sheltering from the day's heat, they took their ease amid fragrant white blossoms and flowering

trees in the cooler night air. The Mughals added pools and water devices to their moonlight gardens and outlined the raised paths, platforms, and pavilions with small oil lamps. All these features were in Shahjahan's Mahtab Bagh, but its main purpose was to view the Taj.

The positioning of the Taj on its lofty setting high above the river and the perfect placement of the octagonal pool to reflect it establish the purpose of the garden in the entire scheme. One imagines the royal barge carrying the emperor from the fort to the garden, where he could sit in an airy pavilion and embrace the dramatic view of the Taj and its ethereal likeness. Magically the image was disembodied by the fountain jets as they fell back in the pearl drop pattern—portraying water as a precious gift from the heavens. His surroundings recall the koranic description of paradise:

> therein a running fountain,
> therein uplifted couches
> and goblets set forth
> and cushions arrayed
> and carpets outspread.
>
> KORAN 88:12–16

Facing Shahjahan was the north portal of the Taj inscribed with Sura 84 "Rending Asunder" wherein this world and the next are sundered by death. Here in his earthly paradise he could enjoy the pleasure of sorrow.

Beyond the riverfront terrace of the Mahtab Bagh are the ghostly traces of a *charbagh*, which no doubt had fruit trees in the plots (see "Botanical Symbolism and Function"). Such gardens evoked the *hasht bihisht*, eight paradises, a reference to paradise in the Koran, and the Mahtab Bagh recalls Sura 55 in which two gardens are mentioned with green pastures, two kinds of every fruit, palm trees and pomegranates.

One of the so-called mysteries surrounding the Taj is the placement of Shahjahan's cenotaph. The queen's cenotaph is centered within screens of marble tracery, but the emperor is crowded to the side, seeming to support speculation that Shahjahan planned to build a second tomb. But his cenotaph was on the west, toward Mecca, and there was precedence for such asymmetrical placement of cenotaphs as seen in the earlier Yamuna garden tomb of I'timauddawla, which is known to be the original design. Another view citing expense, scale, and the attention lavished on every detail argues that Shahjahan built the Taj as his tomb. The epitaph engraved on his cenotaph strengthens this view.

This is the illumined grave and sacred resting place of the Emperor, dignified as Rizwan, residing in Eternity, His Majesty, having his abode in [the celestial realm of] 'Illiyun, Dweller in Paradise, the Second Sahib Qiran, Shah Jahan, *Padshah Ghazi*; may it

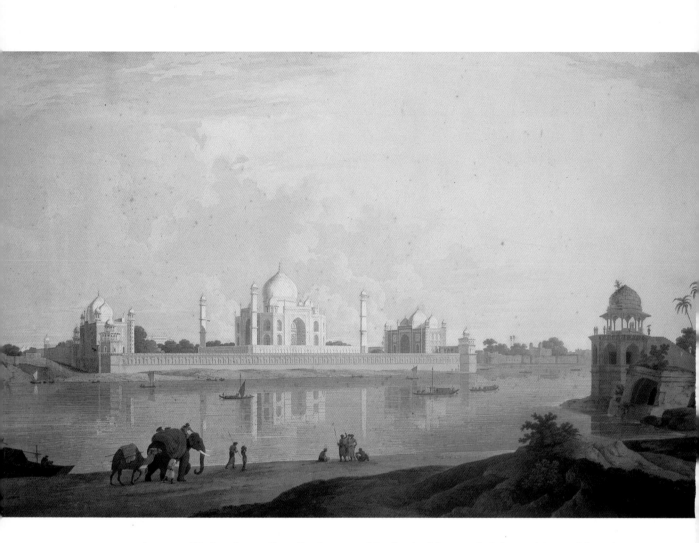

be sanctified and may Paradise become his abode. He traveled from this world to the banquet-hall of Eternity on the night of the twenty-sixth of the month of Rajab, in the year one-thousand-and-seventy-six-Hijri" [January 31, 1666][29]

Here Shahjahan is referred to as "Rizwan," in Islamic tradition the guardian of paradise; the Taj complex is his image of paradise, and he is the gatekeeper to that paradise.

Surely Shahjahan envisaged this ultimate tomb at the ultimate crossing of the Four Rivers of Paradise. Indeed the design of the complex feels incomplete if the tomb on its riverside terrace is considered the northern end of the plan; it lacks the symmetry essential to the Mughal sense of order. At present, to experience the Taj, one progresses past Taj Ganj, through the forecourt to the monumental gate, a prelude framing the first view of the Taj. Within the enclosure the vision of the tomb floating above the plinth pulls you toward it, drawing you along the central watercourse of the formal garden up to the marble terrace. The culmination of the plan at the tomb suspended above the edge of the river is abrupt; it is dramatic but very un-Mughal. There is strong evidence that the Mahtab

William and Thomas Daniell, *The Taje Mahel, Agra*. Originally published as an aquatint (53.3 x 87.6 cm) in *Views of the Taje Mahel at the City of Agra in Hindoostan Taken in 1789*. Used by permission of the British Library P395. In the right foreground the surviving tower of the Mahtab Bagh shows figures on the upper level, stairs leading up to it (no evidence of stairs remains), and a collapsing stone structure, possibly part of an aqueduct.

Site plan of the Taj Mahal complex including the Yamuna River and the Mahtab Bagh in correct proportions. The plan of the Mahtab Bagh is reconstructed rather than conjectural, based on physical evidence from archaeological investigation and early literary references. Measurements of the structures shown in the east and west wall and of the northern gate conform with existing records, but the complete plan cannot be traced. Originally pavilions flanked the octagonal pool, but little beyond their masonry foundations remains; as these building plans were not clear, they have not been included. The plan shows how the size of the tomb and the octagonal pool correspond. It can be seen clearly that the principle of unity so fundamental in Islamic belief and architecture has been achieved in the composition of the Taj complex. The plan may embody Shahjahan's image of the cosmic order, but the analysis of its meaning and the symbolism of its geometric forms have not been deciphered. Plan drawn by Lisa Scheer based on the 1789 engraving by James Newton. (See p. 37.)

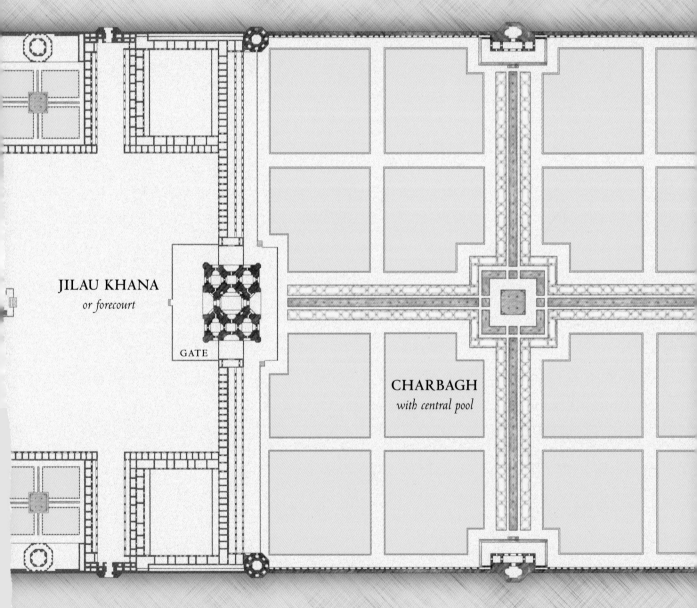

**JILAU KHANA**
*or forecourt*

GATE

**CHARBAGH**
*with central pool*

Plan of the Taj Mahal complex including the Mahtab Bagh

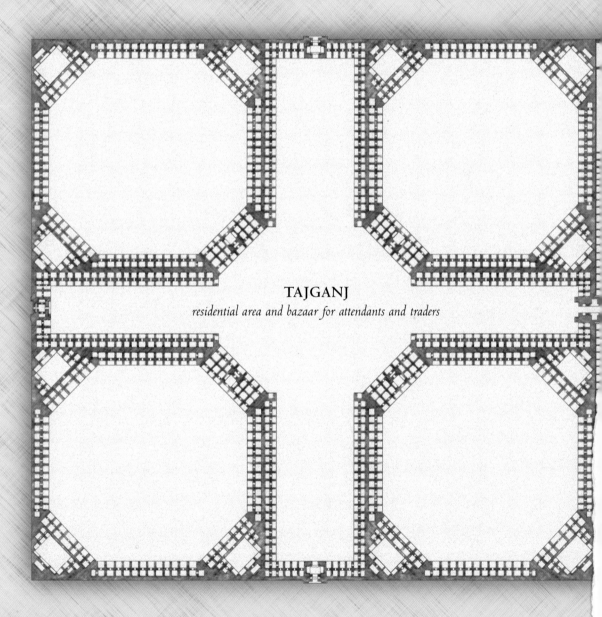

**TAJGANJ**
*residential area and bazaar for attendants and traders*

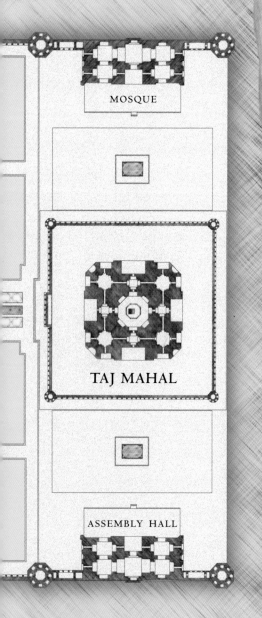

MOSQUE

TAJ MAHAL

ASSEMBLY HALL

*Yamuna River*

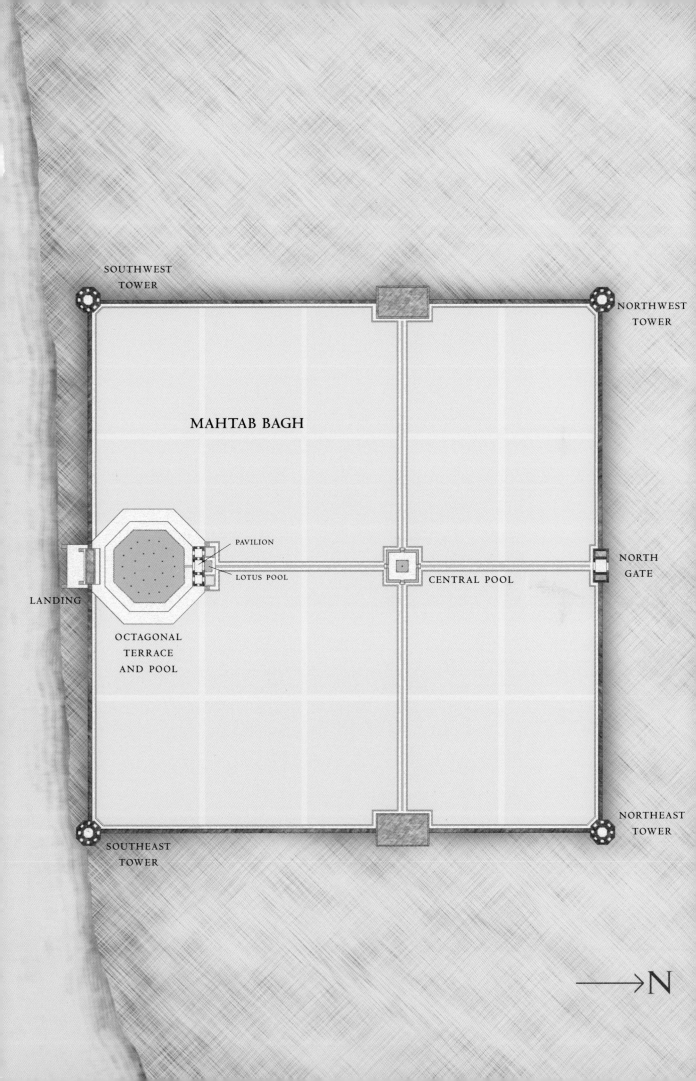

SOUTHWEST
TOWER

NORTHWEST
TOWER

MAHTAB BAGH

PAVILION

LOTUS POOL

LANDING

CENTRAL POOL

NORTH
GATE

OCTAGONAL
TERRACE
AND POOL

NORTHEAST
TOWER

SOUTHEAST
TOWER

→N

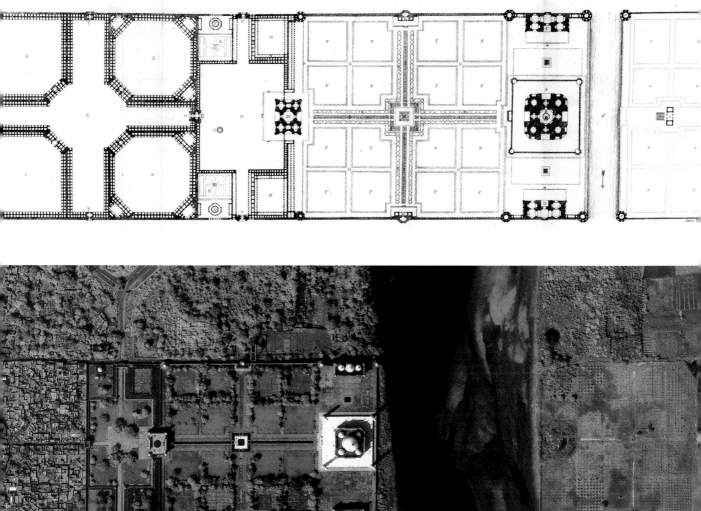

Top: *Plan of the Taje Mahel* engraved by James
Newton. In William and Thomas Daniell,
*Views of the Taje Mahel at the City of Agra in
Hindoostan Taken in 1789.* Used by permission
of the British Library T11333. The artist
reduced the width of the river and
included only a portion of the Mahtab
Bagh.

Taj Mahal with the Yamuna River and the
Mahtab Bagh. Satellite photo, October 10,
1999, by spaceimaging.com

*Reflections of Paradise*     37

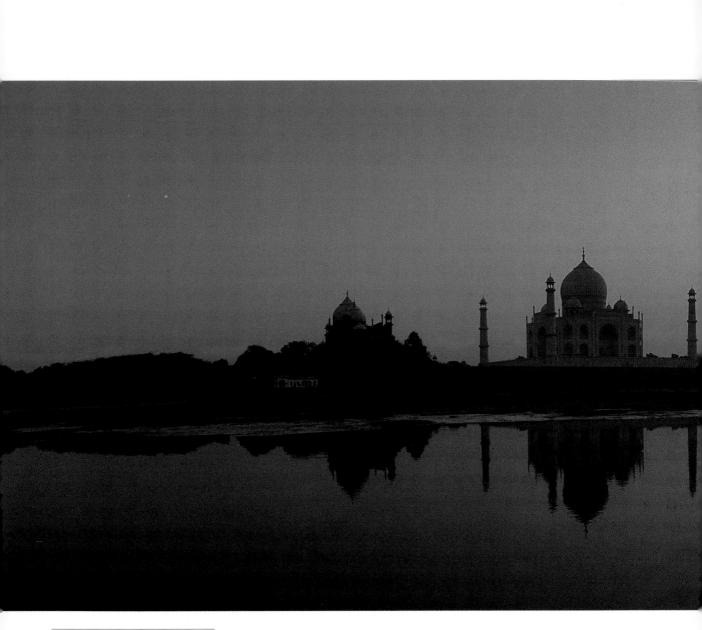

The Taj Mahal and the southeast tower of the Mahtab Bagh reflected in the Yamuna River, in the evening, October 24, 1999. Compare to the Daniells' aquatint (p. 32). Photograph by Neil Greentree

Bagh was part of the original plan of the Taj complex and, though long overlooked, its inclusion demonstrates such a crossing of the Four Rivers. The water channels in Shahjahan's two gardens are aligned and provide one long north-south axis. Follow the water from the channel below the entrance gate of the Taj enclosure to the raised tank in the center: it divides to circle the tank and glides on to disappear beneath the monumental plinth, then rises joyfully in the fountains of the octagonal pool of the Mahtab Bagh, from which it falls in a cascade to the lotus pool, and overflows into a channel that runs to the central tank of the *charbagh*, an image of the pool within the Taj enclosure.

The River Yamuna itself becomes part of this bold concept joining—rather than separating—the two gardens. The crossing of the rivers is consummated as the Yamuna, flowing west to east past the tomb, passes over the illusory water channels. Thus when reflected in the river, the Taj, the sacred mount as *axis mundi*, is transformed into an evanescent image above the crossing of the Four Rivers of Paradise.

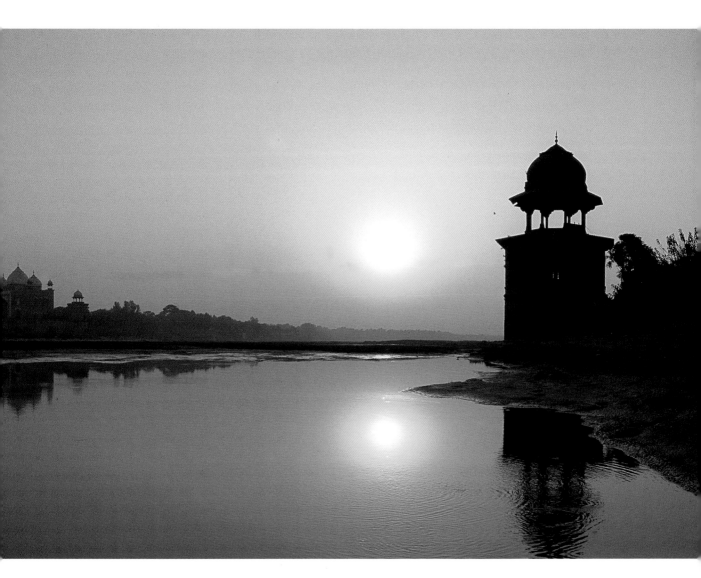

Only someone with Shahjahan's vainglorious sense of himself could conceive such an audacious plan. However, as realized, this plan of the Taj transcends all others as the vision of paradise on earth, Shahjahan's own cosmic diagram.

> Surely the godfearing shall dwell amid gardens
> and a river
> in a sure abode, in the presence of
> a King Omnipotent.
>> KORAN, Sura 54 "The Moon"

## AFTERWORD

In October 1999 as we were puzzling over the worn stone remnants of the structure that once graced the wall, one of the workmen clearing grass and soil offered an explanation; it was the frame of a large window or a door, the holes were sockets for heavy shutters, the

rusted iron looped through a hole was a fragmentary latch. He explained it was just like a house in the village; that proved to be the ruined hulk of a Mughal mahal now housing dozens of village families. Early sketches of the Mahtab Bagh include a narrow structure with shuttered windows, a vaulted roof, and a curved cornice above the wall. In Shahjahan's time such vaulting, called *bangla,* were reserved for royalty. We had found sections of such a curved cornice in the debris where the vaulted chambers against the wall beneath the walk and part of the pool had collapsed.

In keeping with the recent Supreme Court of India ruling to establish a greenbelt around the Taj, in 1998–99 the Horticulture Department of the ASI planted seven-thousand saplings in the quadrants of the Mahtab Bagh north of the riverfront terrace. Tapping the irrigation system provided for the plantation, we were able to collect water in the octagonal pool. By the light of the full moon on October 24, 1999, the Taj was reflected once again in the great pool of the Mahtab Bagh. In the stillness of the night, bathed in moonlight, the glory of the garden could be imagined.

From the top of the wall above the garden's ruins, the now abused and wounded Yamuna appeared magisterial once more with the serene image of the Taj floating on its silver surface. Just west of the moonlit tomb the fires of the cremation ghat flickered when reflected in the holy Yamuna, the ageless witness to the death of men and dynasties, as it rolled on its timeless path to union with the Ganga. ◪

NOTES

1. Zahiru'd-din Muhammad Babur, *Memoirs of Babur,* trans. Annette Susannah Beveridge (London: Luzac & Co., 1971), p. 525.

2. Babur is credited with introducing the Persian wheel to Agra, but evidence suggests that his wells used water lifts drawn by animals walking a ramp. However, Persian wheels appear in gardens in paintings; some may have been original, others replaced. A Persian wheel raises well water and discharges it into a canal by pots attached to the rim. The vertical wheel is geared to and propelled by a horizontal wheel driven by an animal circling the well.

3. Babur, *Memoirs of Babur,* trans. Beveridge, p. 532.

4. See Ruy Gonzalez de Clavijo, *Embassy to Tamerlane, 1403–1406,* trans. Guy le Strange (New York: Harper & Bros., 1928), pp. 218–22, 226–30. The chapters on Samarkand also contain colorful descriptions of elegant fabric pavilions and enclosures within these gardens, much like those in later Mughal camps.

5. Galina A. Pugachenkova, *The Art of Central Asian Gardens and Parks in the Time of Tamerlane and the Timurids* (Tashkent, USSR: Works of the Central Asian State University, Ministry of Higher Education, 1951), pp. 143–68.

6. Thomas W. Lentz and Glenn D. Lowry, *Timur and the Princely Vision* (Washington, D.C.: Smithsonian Institution Press, 1989). This is the excellent, and only, source on the relationship between Timurid art and its political and historical context.

7. Elizabeth B. Moynihan, "The Lotus Garden Palace of Babur," *Muqarnas* 5 (1988): 135–52.

8. Zayn Khan, *Tabaqat-i Baburi,* trans. Sayed Hasan Askari (Delhi: Idarah-i Adabiyat-i 1982), p. 156.

9. Thomas W. Lentz, "Memory and Ideology in the Timurid Garden," in *Mughal Gardens: Sources, Places, Representations, and Prospects,* ed. by James L. Wescoat Jr. and Joachim Wolschke-Bulmahn (Washington, D.C.:

Dumbarton Oaks Research Library and Collection, 1996), pp. 31–57.

10. Annemarie Schimmel, "The Celestial Garden in Islam," in *The Islamic Garden* (Washington, D.C.: Dumbarton Oaks, 1976), p. 21.

11. Babur, *Memoirs of Babur*, trans. Beveridge, pp. 531–32.

12. Ibid., p. 532.

13. 'Inayat Khan, *The Shahjan Nama*, trans. A. R. Fuller, ed. W. E. Begley and Z. A. Desai (Delhi: Oxford University Press, 1990), p. 92.

14. Jahangir, *The Jahangirnama: Memoirs of Jahangir, Emperor of India*, trans. and ed. Wheeler M. Thackston (New York: Oxford University Press, 1999), p. 24.

15. Maulvi Moin-ud-din Ahmad, *The Taj and Its Environments* (Agra: R. G. Bansal & Co., 1924), pp. 114–15.

16. Abu'l-Fazl Allami, *Ain-i Akbari*, trans. H. S. Jarrett, ed. Jadunath Sarkar (1867–77; reprint, New Delhi: Oriental Books Reprint Corp., 1978), 2:191.

17. Nineteenth-century engravings show the walls as rubble. They were rebuilt after Lord Curzon appointed Sir John Marshall as director general of the Archaeological Survey, when the department was given a clear mission for preservation.

18. Babur, *Memoirs of Babur*, trans. Beveridge, p. 208.

19. Quoted in Joannes de Laet, "Topography of the Mogul Empire in the Sixteenth and Seventeenth Centuries," trans. in *Part II Calcutta Review* (Calcutta: Thomas S. Smith; London: Trubner & Co., 1871), p. 67.

20. Shahjahan had a Rajput Hindu mother and grandmother, but although he was three-quarters Rajput he was a more observant Muslim than his father or grandfather.

21. See Catherine Asher's indispensable book, *Architecture of Mughal India* (Cambridge: Cambridge University Press, 1871), in which she notes that for the first time during this period many noble women became patrons of public architecture.

22. Rooted in symbolism, Islamic gardens resisted outside influences, but the Moorish gardens in Spain were influential throughout the Mediterranean and the Islamic gardens in Sicily affected garden development in Italy. Familiar with Italian gardens, Richelieu's architect, Jacques Leerier, admired Turkish design as did Andre Le Notre, the greatest of the French landscape architects.

23. Milo Cleveland Beach, Ebba Koch, and Wheeler M. Thackston, *King of the World: The Padshahnama, An Imperial Mughal Manuscript from the Royal Library, Windsor Castle* (London: Azimuth Editions; Washington, D.C.: Arthur M. Sackler Gallery, 1997), p. 131.

24. Amine Okada, Jean-Louis Nou, and M. C. Joshi, *Taj Mahal* (New York: Abbeville Press, 1993), pp. 218–25.

25. R. Nath, *The Immortal Taj Mahal* (Bombay: D. B. Taraporevala Sons & Co., 1972), p. 80. Nath notes such wells, used to neutralize the thrust of the river, were built at most garden sites along the riverbank.

26. Wayne E. Begley, "The Myth of the Taj Mahal and a New Theory of Its Symbolic Meaning," *Art Bulletin*, March 1979, pp. 7–35.

27. François Bernier, *Travels in the Mogul Empire*, trans. Irving Brock, ed. Archibald Constable (1891; reprint, New Delhi, S. Chand & Co., 1968), p. 295.

28. Jean Baptiste Tavernier, *Tavernier's Travels in India*, trans. and ed. V. Ball (London: Macmillan and Co. 1889), 1:111.

29. Wayne E. Begley and Ziyauddin A. Desai, eds., *Taj Mahal, The Illumined Tomb—An Anthology of Seventeenth Century Mughal and European Documentary Sources* (Cambridge, Mass.: Aga Khan Program for Islamic Architecture, 1989), p. 193. See also this chapter, p. 28, "Letter from Aurangzeb to Shahjahan." Original text from Begley, pp. 174 and 176.

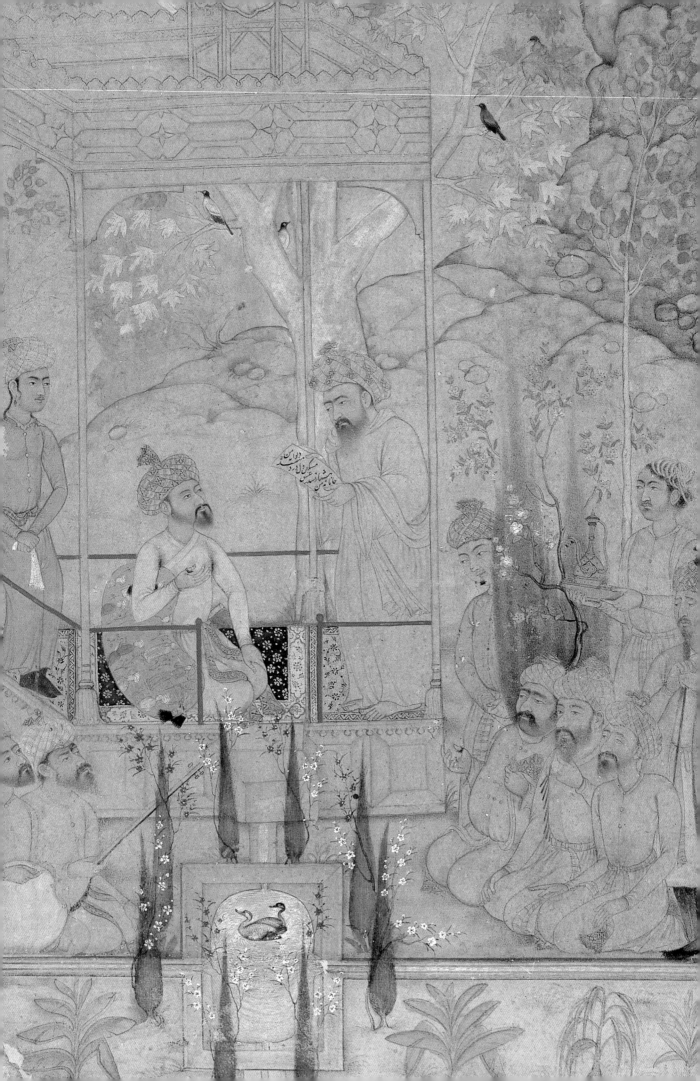

# Botanical Symbolism and Function at the Mahtab Bagh

*David L. Lentz*

MODELED AFTER THE Persian concept of earthly paradise, the pleasure gardens of the seventeenth-century Mughal emperors exhibited elaborate renditions of cut-stone architecture, water chutes, standing pools, and flowing fountains, but their very essence was revealed in carefully managed floristic displays. The layout and design of these gardens were filled with symbolic meaning that was a direct reflection of Mughal thought and rich iconographic history. Yet not everything about Mughal gardens was symbolic. Gardens were places of respite and enjoyment where all the senses could be stimulated. Each garden was designed to evoke the sounds, smells, touch, taste, and visual richness of paradise on earth. Many of the sensual attributes were arranged through the plantings. Of course, tied in with the symbolism and sensuality was a need to be practical; gardens were refuges from the torrid summers and lengthy monsoons of India. Agra, with its notoriously warm climate, represents an excellent justification for such refreshing sanctuary. Cool, rippling waters coupled with shade from overarching broadleaf trees were key elements to the natural climate control of the gardens.

Although the Mughals brought a rich garden tradition with them to central India, many of their architectural elements and selections for plantings were influenced by Hindu garden concepts. Starting with Akbar, grandfather of Shahjahan, the Mughal emperors made a political point of marrying Indian princesses to win the allegiance of local rulers.[1] It was during Akbar's reign that women began to affect garden design and patronage.[2] Indeed, Shahjahan's mother, first wife of Jahangir, was a Rajput princess.[3] The Rajput clans formed a major portion of the Hindu warrior caste and thus were important allies to the Mughal conquerors. As Indian women became more involved with life at court, they were able to introduce their tastes and preferences into its proceedings. Furthermore, pleasure gardens themselves were built and tended by Indian artisans and workers. As a result, there were

considerable opportunities for Indians to influence the construction and floristic design of the gardens.

Because Mughal gardens were intended to be well-ordered oases in an otherwise hot, dusty, and chaotic environment, they served as social centers for many of the rituals and special occasions of courtly life. The beauty and fragrances provided by the floral displays offered a colorful backdrop for major events such as birthdays, coronations, marriages, and even, in some cases, entombment.[4] The availability of fresh flowers and fruits was undoubtedly an attractive feature of the gardens. The horticultural arrays were not only alluring settings with symbolic representations; the plants were placed there to serve an economic function, too. Fruit production at gardens would often exceed the needs of the royal family, and the surplus could be sold in local markets to offset the high cost of garden maintenance.[5] In this way, both immediate and long-term needs could be satisfied, and the gardens could be rendered self-sustaining.

In short, pleasure gardens reflected the religious and political symbolism of seventeenth century Mughals combined with syncretic influences from local traditions. The gardens served as centers of court activities in an environmentally and aesthetically pleasing setting. They were places of luxurious abundance where the bounty could be enjoyed by the royal court or sold to defray costs.

MODERN FLORISTIC INVENTORY OF THE MAHTAB BAGH

Although only remnants of its former glory still exist, the Mahtab Bagh was an excellent example of a seventeenth-century Mughal pleasure garden. Its location across the Yamuna River from the Taj Mahal in the former Mughal capital, Agra, provides a breathtaking context with an unparalleled vista. The vegetation that currently shrouds the Mahtab Bagh and its surroundings is quite different from the manicured garden of Mughal times, and no doubt the well-ordered splendor of the former earthly paradise gave way long ago to cosmopolitan weeds and other invasive species. Despite the ravages of time, the best place to start when investigating the vegetation of the past is to learn what exists in the present. Following this simple maxim I began my fieldwork in India by collecting as many plants as possible from the environs of the Mahtab Bagh. The names, both local and scientific, of plants examined, along with their uses are listed in Table 1 (see p. 56). There were several reasons to complete this exercise. First, the specimens served as vouchers that documented the modern vegetation. Second, the collection of modern plants from the vicinity could be used as reference material for the identification of archaeological plant remains that were retrieved from excavations at the site. Finally, the floristic inventory helped provide indirect insights into the kind of plants growing there in the past. For example, it is not

Page 42: *Emperor Babur with Attendants in a Garden Pavilion,* India, ca. 1605. Color and gold on paper, 19.1 x 12.2 cm. Freer Gallery of Art, Smithsonian Institution, Purchase F1954.27. Eight cypress trees are illustrated in the foreground.

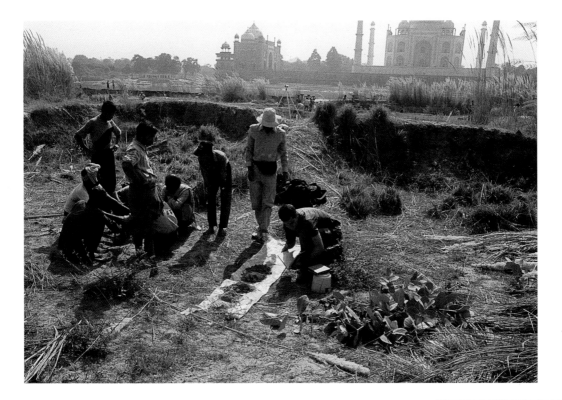

unusual for trees to live two hundred years and even longer. With this in mind, it is easy to imagine that the trees of today's Mahtab Bagh could be the second- or even first-generation descendants of the planted denizens of the emperor's garden.

After inspection of Table 1, even the most casual observer will note that many of the plants listed are weedy species that have made what remains of the Mahtab Bagh their home in recent years. This result is to be expected at a riverfront site that more than once has suffered the disturbance of floodwaters. Much of the north side of the river is cultivated, so a number of annual cultigens are listed as well. There are, however, several examples of useful plant species currently growing at the Mahtab Bagh that merit special comment.

Two plants that were common at the modern site include *phuse* and *guava. Phuse (Saccharum munjo* Roxb.) is a tall grass related to sugar cane that was the visually dominant plant at the site (fig. 1) when I arrived there in 1996. Local farmers used the grass stems to weave baskets and mats and enjoyed a brisk trade in the products. The *phuse* grass, to the displeasure of the basket weavers, has since been cleared to make way for excavations and new plantations.

Guava trees (*Psidium guajava* L.), introduced from the Americas, were planted in an orchard in the southwest corner of the Mahtab Bagh. This orchard is probably not a relic of the Mughal period. While it is true that the Mughals readily adopted a number of New World crops soon after the Age of Discovery,[6] and guava was one of them, the guava orchard at Mahtab Bagh seems to have been planted in the late twentieth century.

Figure 2. The *laswora* tree (*Cordia myxa* L.) with its edible fruits is a common sight at the Mahtab Bagh today. Photographed in 1998 by David L. Lentz

Several examples of the *laswora* tree (*Cordia myxa* L.) can be found within the Mahtab Bagh compound today (fig. 2). This medium-sized tree produces edible fruits that are employed in native medicinal treatments. The bark is a good source of fiber for ropes, and the wood has many uses.[7] Even though no records by Mughal historians exist for the use of *laswora*, the tree is often planted at reconstructed Mughal garden sites.

Mangoes (*Mangifera indica* L.) are common trees in the flood plains adjacent to the Mahtab Bagh. Mango, or *am*, was mentioned in the *Baburnama* (Memoirs of Babur) as a highly regarded fruit. Indeed, Babur described mango as, "the best fruit in Hindustan."[8] The trees are illustrated frequently on the walls of tombs, palaces, and monuments. Mangoes are remarkably well adapted to the climate and soil conditions of the Yamuna Valley, and, as a result, the local mangoes are extraordinarily sweet and flavorful. In addition to bearing delicious fruit, the plant has a number of medicinal applications, including a cure for dysentery derived from the seed kernel.[9] Accordingly, it is hard to imagine a Mughal pleasure garden in Agra without mangoes.

Another tree found within the Mahtab Bagh compound today is the sugar palm (*Phoenix sylvestris* Roxb.) (fig. 3), a close relative of the date palm (*P. dactylifera* L.). Sugar palm is cultivated throughout India and Burma for its fruits and sap, which can be fermented to make toddy. Owing to their random distribution, the sugar palms in the Mahtab Bagh compound appear to have volunteered. The Mughals used palms extensively in their pleasure gardens although other species, such as date palm, coconut (*Cocos nucifera* L.), and the palmyra palm (*Borassus flabelliformis* Murr.), were more commonly mentioned in historic accounts.

A number of fig trees were observed at the modern site, mostly in association with the remains of the waterworks. One of these was the banyan (*Ficus benghalensis* L.) tree (fig. 4). These are sacred trees to the Hindus and were much admired by Jahangir and other Mughals because of their curious habit of sending down aerial roots to help support the weight of the tree.[10] Many treatments in ayurvedic medicine are derived from this valuable tree. Another fig that grows at the Mahtab Bagh today, known as *gular* (*F. glomerata* Roxb.) to the Mughals, was listed in the *Baburnama* as a preferred garden shade tree.[11] This tree bears edible fruit and is a source of a variety of medicines.

The jujube (*Zizyphus jujuba* Lam.) is another useful tree (fig. 5) that grows today at the Mahtab Bagh site. It produces edible fruits (called *ber* by the Mughals), has medicinal applications, and was listed by Babur as a typical garden tree.[12] The trees found at the site today may indeed be feral descendants of trees originally planted by the Mughals.

## ARCHAEOBOTANICAL APPROACHES

After the floristic inventory of the modern environs of the Mahtab Bagh was completed, I shifted the focus of my investigation to plant remains associated with Mughal period archaeological deposits. The purpose of this aspect of study was to retrieve and examine preserved plant materials that could tell us what plants were growing in the Mahtab Bagh during the mid-seventeenth century. In the first season (1996), I worked closely with John Fritz (see "Archaeology of the Garden") and members of the Archaeological Survey of India. Our initial objective was to put in test pits that would reveal the stratigraphy of the site and identify buried Mughal activity surfaces and other recognizable features that related to the same time period. This task proved to be more difficult than initially expected. From historical records we knew the site had been flooded at least once since Mughal times and probably more often. The heavy deposition of river sediments (several meters thick in some areas) caused by flooding made excavating an arduous task. Fortunately, we came equipped with a coring device that allowed us to assess the stratigraphy rapidly in spite of the deep overburden. Using the coring device as well as through direct sampling, we were able to collect about three dozen soil samples for pollen extraction. Attempts to extract pollen in the laboratory (fig. 6) from selected soil samples revealed that conditions at the site were not conducive to the preservation of pollen.

Figure 3. A sugar palm (*Phoenix sylvestris* Roxb.) at the Mahtab Bagh, 1996. Photograph by David L. Lentz

Figure 4. Botanical illustration of a banyan tree (*Ficus benghalensis* L.). Archives of The LuEsther T. Mertz Library at the New York Botanical Garden

Figure 5. Botanical illustration of a jujube tree (*Zizyphus jujuba* Lam.). Archives of The LuEsther T. Mertz Library at the New York Botanical Garden

Figure 6. Mahtab Bagh soil samples analyzed for their pollen content. All samples lacked sufficient pollen counts for reliable interpretation.

With a better understanding of the stratigraphy at the site and the knowledge that additional sampling for pollen from Mahtab Bagh sediments would be fruitless, I concentrated my efforts during the 1998 season on archaeological contexts showing minimal signs of disturbance. Data retrieval was based on careful excavation and sifting all excavated soil with fine mesh screens. Extensive sampling for charred macroremains that could be recovered using water flotation was implemented for all contexts.

This modified strategy focused on intact activity surfaces in different parts of the garden. Identifiable plant materials were collected in three strategic locations: the plaster walkways along the inside south wall, activity surfaces associated with the "central feature," or square pool and the surrounding terrace at the center of the *charbagh*, and the interior plas-

| SAMPLE NUMBER | GENERAL PROVENANCE |
|---|---|
| DL1 — BP3 | Fountain pool, sediment surface |
| DL2 — BP8 | Plaster surface of octagonal pool adjacent to eastern wall |
| DL3 — BP9 | Above plaster floor near western wall in octagonal pool |
| DL4 — BP12 | From below plaster near western wall in octagonal pool |
| DL5 — P#12 | From pollen column in test pit #1, 48 cm below ground surface |
| DL6 — Pollen column, 350 cm below ground surface, clay below brick on mortar surface in test pit #2 | |

CUPRESSUS *sempervirens.* КИПАРИСЪ.

*Michelia montana*

plaster walkways that articulate with the *burj* (or tower) in the north-east corner of the site. Each of these contexts had at least some strata that were undisturbed, and all yielded plant material from the Mughal period. All archaeobotanical materials were analyzed using light and electron microscopy at the New York Botanical Garden's Plant Research Laboratory.

I will begin the discussion of the archaeological plant data starting at the south end, which was actually the front end or entrance side of the garden. A test pit adjacent to the south wall of the compound was excavated by James L. Wescoat (see "Waterworks and Landscape Design") who uncovered two superimposed activity surfaces. These were the remains of two plaster walkways that followed the inside of the exterior brick wall of the site and probably continued around the inside of the garden compound. At some point the Mughals rebuilt or resurfaced the walkways so that in profile they appear to be one on top of another.

Two burned wood samples were recovered from the lower surface of the south compound wall test pit. The first was from cypress (*Cupressus sempervirens* L.) and the other was red cedar (*Toona ciliata* M. J. Roem.). Cypress (fig. 7) was one of the most favored trees at Mughal gardens throughout the realm. The other tree from the activity surface in the southern test pit, red cedar, tends to be a large (25–30 meters) tree in the wild, but when cultivated grows only 4–6 meters tall and is referred to in the botanical literature as a

Figure 7. Botanical illustration of cypress (*Cupressus sempervirens* L.). Archives of The LuEsther T. Mertz Library at the New York Botanical Garden

Figure 8. Botanical illustration of a *champa* tree (*Michelia* sp.). Archives of The LuEsther T. Mertz Library at the New York Botanical Garden

*Celosia*

Figure 9. Botanical illustration of a cockscomb (*Celosia cristata* L.) plant. Archives of The LuEsther T. Mertz Library at the New York Botanical Garden

"handsome tree."[13] Red cedar is in the mahogany family and should not be confused with the coniferous true cedars. The name red cedar comes from the timber, which resembles cedar in color, but otherwise the trees are quite different in terms of anatomy and evolutionary relationships.

From the surface adjacent to the square pool in the center of the *charbagh,* a charred wood sample from the Anacardiaceae (cashew) family was identified. This sample compares well to *chirunji* (*Buchanania latifolia* Roxb.). The fruits of *chirunji* can be eaten fresh or roasted. At a height of 18 meters it makes an excellent shade tree and is widely planted as an ornamental because, although deciduous, it loses its leaves but regrows them quickly.[14] Charred wood from this species was also found above an activity surface near the northeast *burj,* so the tree appears to have been widely planted at the north end of the site.

Jujube charcoal was found near the same context as the *chirunji* wood. As mentioned above, jujube produces tasty fruits and was noted as a garden favorite in the *Baburnama.*

From just above the lower activity surface near the northeast *burj* came a charred wood sample from a *champa* tree (*Michelia* sp.) (fig. 8). This tree, a member of the magnolia family, produces large, showy, and fragrant flowers that bloom at night—perfect for a "moonlight garden."

Another curious botanical find came from the upper walkway near the northeast *burj.* A carbonized cockscomb seed (*Celosia cristata* L.) was found embedded in the activity surface. This is an herbaceous plant with a bright red inflorescence (fig. 9). In addition to its colorful flowers, it produces abundant seeds that are attractive to songbirds. The *Humayannama* (Memoirs of Humayan) recorded the use of cockscomb as a party decoration at Agra's Mystic House, and European visitors to the Agra region observed this plant growing in Mughal gardens during the mid-seventeenth century.[15]

Although our inventory of plants from the Mahtab Bagh represents only a fraction of the total plants used, an outline of some of the floral arrangement comes into view. At the south end of the garden we have evidence for cypress and red cedar. Remains of *chirunji* were unearthed from Mughal period strata at the center of the *charbagh.* At the north end of the site, archaeobotanical analysis indicates the presence of *champa,* jujube, cockscomb, and more

Figure 10. Lotus carved pool, Mahtab Bagh, 1999. Photograph by Neil Greentree

*chirunji.* All these plants have a long history of use as horticultural varieties in Mughal or Indian gardens. The combination of species and their locations within the garden provide an interesting glimpse into the way the Mahtab Bagh appeared at its zenith in the seventeenth century.

## HORTICULTURAL DISPLAY IN THE MAHTAB BAGH

The archaeobotanical data suggest a number of intriguing aspects of the floral arrangement at Mahtab Bagh and, at the same time, reveal something about the aesthetic preferences of the garden designers. First, let us examine the layout of plants at the garden, which—presumably—was planned carefully. At the south end near the entranceway there is evidence of cypress and red cedar trees. Often Mughal gardeners planted trees in rows with cypresses alternating with larger shade trees. The red cedar trees could easily have served the latter function. In addition, red cedar has extremely fragrant, night-blooming white flowers that would have enhanced any moonlit visitation. Thus it seems that the south end of the garden, the main entrance, would have had the most formal appearance provided by a potentially contrapuntal arrangement of the neat, geometric cypresses and the high-arching, sweet-smelling red cedars.

Farther to the north in the garden at the center of the *charbagh*, we find the *chirunji* tree with its sweet kernels that taste much like pistachio nuts (these two trees are closely related). It seems that *chirunji* was planted in more than one location because we find evidence of the same species at the north end of the site. This tree would have been an excellent choice for the garden because it provides shade for most of the year and produces edible fruits as a visitor's delight.

Figure 11. A representation (cut-stone inlaid in marble) of a lotus flower at the Taj Mahal, 1999. Photograph by Neil Greentree

At the far north end of the site (the back end) we find more evidence of *chirunji* plus jujube, cockscomb, and *champa*. Here can be seen a floral composition that touches all the senses: jujube and *chirunji* have tasty fruits; cockscomb and *champa* have beautiful flowers; *champa* is famous for its outstanding fragrance; and cockscomb produces abundant seeds for songbirds to enhance an auditory effect. Even this limited set of plants projects the impression of thoughtful horticultural planning.

The archaeobotanical inventory at the Mahtab Bagh offers some insight into the design of the plantings of the garden, and, if we look carefully, it also suggests something about the designers of the garden. By examining the phytogeographic and historic background of each plant we can attempt to answer these questions: Where did the garden plants originate and with what culture were they most closely affiliated?

The cypress, originally from Asia Minor, Iran, and Syria,[16] was probably a Mughal introduction. Symbols of eternity, cypresses were planted by the Persians in their gardens (the models for Mughal gardens), and images of the trees appear in painted works in many places where idealized versions of paradise gardens are depicted.[17]

Although not found among the plant remains retrieved from the site (undoubtedly due to the nature of the soft tissues of the plant), stylized designs of the lotus plant were carved into the scalloped edges of the large octagonal pool at the south end of the Mahtab Bagh. The lotus (figs. 10–12) was a common symbol of fertility and widely portrayed in representational imagery throughout the Mughal realm. The presence of the lotus symbols at the large octagonal pool clearly suggests that the plant itself was grown in one of the many pools of the garden. Similarly, there are numerous lotus flowers at the Taj Mahal (see fig. 11). Both Mughals and Hindus shared an appreciation for its beauty and symbolic meaning.

Red cedar has a natural distribution from Pakistan to Australia.[18] The tree is widely planted throughout India along roadways and in gardens. Although there are no records of the tree in Mughal historic accounts, plant inventories for Mughal period gardens are mostly anecdotal and rarely exhaustive. Here the archaeobotanical record tells us something beyond what is available in the historic record. In any case, the planting of the red cedar at Mahtab Bagh undoubtedly would have been a Hindu-influenced selection.

The *chirunji,* found in the center of the *charbagh* and near the

Figure 12. The sacred lotus flower
(*Nelumbo nucifera* Gaert.), 1996. Photograph
by David L. Lentz

northeast *burj,* is a tree listed in Babur's memoirs, yet its natural distri-
bution extends from India to Burma. Thus it seems likely the Mughals
encountered this tree after their venture down the Khyber Pass. Although the Mughals may
have embraced the use of *chirunji* after they arrived in India, it was the Indians who first cul-
tivated it.

The jujube is another tree with a long history of cultivation in India.[19] Today it is cul-
tivated throughout tropical Asia and Africa, but its center of domestication is in India. In
Indian mythology, jujubes are associated with the direction north.[20] Curiously, evidence for
jujube was found only at the north end of the garden. This finding may be a coincidence,
but it opens the hypothesis that plants symbolically related to different directions were
planted according to the cardinal directions at Mahtab Bagh.

The *champa* tree is mentioned in Indian philosophical treatises as far back as the Gupta
period (ca. A.D. 320). The bark and fruits are used in ayurvedic medicine, and the flowers are
considered appropriate offerings at Hindu temples. In the past, Hindu women are said to
have ornamented themselves with fresh flowers and anointed their hair with oil extracted
from the flowers. Myths involving *champa* are interwoven into tribal folklore in India. For
example, it is believed that the tree is the incarnation of the Goddess of Wealth.[21] The
species of *champa* (*M. oblonga*)[22] found at the Mahtab Bagh originates in the evergreen forest
of Bangladesh.[23] Here again, although the Mughals recognized the excellence of this tree, it
was a plant domesticated by Indians.

*Botanical Symbolism and Function at the Mahtab Bagh*     53

Finally, we come to the cockscomb with its bright vermilion inflorescence. Humayan decorated his feast halls with cockscomb, and travelers observed it in seventeenth-century Mughal gardens, so it is no surprise to find it among the remains at the Mahtab Bagh. Its origin, however, is something of a mystery. It appears that it was first domesticated in the East Indies,[24] but how it got to India is unknown. The Mughals coming from Central Asia were probably not the agents of introduction. More likely, this ornamental was in use by the Indians before the Mughal vanguard crossed the Indus River, and they later adopted the use of this attractive flower.

INTERPRETATION OF THE EVIDENCE

Of the six archaeobotanical garden plants identified at Mahtab Bagh, only one—cypress— was a Mughal introduction; the other five have a long history of use in India and connec- tions with Indian folklore. Notwithstanding a small sample size, it appears that the plantings at the Mahtab Bagh during Mughal times bear more of an Indian imprint than a Mughal one. How could this have happened in the capital city of the powerful Mughal emperors? The answer may lie with the Rajput queens.

After all, the Mahtab Bagh is a moonlight garden, a concept of Hindu origin.[25] As part of this concept, unlike the traditional sunlight gardens of earlier Mughal times, moon- light gardens featured night-blooming plants and white plastered walkways. These are exactly what we find at the Mahtab Bagh. The sweet-scented flowers of the night-blooming red cedar and *champa* trees would have been at their best in the evening, and the white walk- ways made it easier to see while strolling in the moonlight.

The presence of so many Indian plants at the Mahtab Bagh may have a pragmatic explanation. The Mughals originated in Central Asia, and most of the plants they were familiar with were adapted to a temperate climate. Plants like cherries, plums, apples, and aspens that would grow well in Central Asia and Kashmir and are cited extensively in Mughal written accounts would wither in the hot climate of Agra. There are records describing how Akbar tried to impose his imperial will over the growth habits of plants when he tried to import apple trees from Samarkand to Agra, even though they needed to be watered nine months of the year.[26] Undoubtedly, Herculean efforts of this kind were the exception rather than the rule, and planting Indian horticultural varieties adapted to the extreme heat would have made for easier maintenance and happier princesses. Accordingly, the architecture at Mahtab Bagh reflects the grandeur of the Mughal emperor, but the plants in the garden reveal a strong Indian influence. The Mughals may have conquered politically and covered the landscape with their architectural gems, but the refinements of Indian horticultural prowess seem to have held sway at the Mahtab Bagh. ▣

## NOTES

I would like to extend special thanks to Elizabeth Moynihan for guidance, insight, kindness, and years of hard work that brought this project to fruition.

1. G. H. R. Tillotson, *Mughal India* (London: Penguin Books, 1990), p. 12.

2. James L. Wescoat Jr. and Joachim Wolschke-Bulmahn, eds., *Mughal Gardens: Sources, Places, Representations, and Prospects* (Washington, D.C.: Dumbarton Oaks Research Library and Collection, 1996), p. 8.

3. Elizabeth B. Moynihan, *Paradise as a Garden in Persia and Mughal India* (New York: George Braziller, 1979), p. 130.

4. Wescoat and Wolschke-Bulmahn, eds., *Mughal Gardens*, p. 8.

5. Irfan Habib, "Notes on the Economic and Social Aspects of Mughal Gardens," in *Mughal Gardens*, ed. Wescoat and Wolschke-Bulmahn, pp. 127–37.

6. Sylvia Crowe, Sheila Haywood, Susan Jellicoe, and Gordon Patterson, *The Gardens of Mughul India* (London: Thames and Hudson, 1972), p. 191.

7. J. S. Gamble, *A Manual of Indian Timbers* (London: Sampson Low, Marston & Co., 1902), p. 471.

8. Babur, quoted in Crowe, Haywood, Jellicoe and Patterson, *Gardens of Mughul India*, p. 190.

9. Naveen Patnaik, *The Garden of Life: An Introduction to the Healing Plants of India* (London: Harper Collins Publishers, 1993), pp. 19, 164.

10. Ibid.

11. Crowe, Haywood, Jellicoe, and Patterson, *Gardens of Mughul India*, p. 194.

12. Ibid.

13. S. K. Purkayastha, *A Manual of Indian Timbers* (Calcutta: Sribhumi Publishing Company, 1997), p. 165.

14. Gamble, *Manual of Indian Timbers*, p. 216.

15. Crowe, Haywood, Jellicoe, and Patterson, *Gardens of Mughul India*, p. 68.

16. Gamble, *Manual of Indian Timbers*, p. 697.

17. Crowe, Haywood, Jellico, and Patterson, *Gardens of Mughul India*, p. 20.

18. Purkayastha, *Manual of Indian Timbers*, p. 165.

19. J. W. Purseglove, *Tropical Crops: Dicotyledons*, p. 642.

20. Constance M. Villiers Stuart, *Gardens of the Great Mughals* (London: Adam and Charles Black, 1913), pp. 243–55.

21. Patnaik, *Garden of Life*, pp. 19, 164.

22. K. A. Chowdury and S. S. Ghosh, *Indian Woods*, vol. 1 (Delhi: Survey of India, Dehra Dun, 1958), p. 11.

23. Gamble, *Manual of Indian Timbers*, p. 13.

24. Alfred Byrd Graf, *Tropica: Color Cyclopedia of Exotic Plants and Trees*, 3d ed. (East Rutherford, N.J.: Roehrs Company, 1986), p. 969.

25. Villiers Stuart, *Gardens of the Great Mughals*, pp. 243–55.

26. Crowe, Haywood, Jellicoe, and Patterson, *Gardens of Mughul India*, p. 191.

## Table 1. Current Vegetation of the Mahtab Bagh and Vicinity

| Scientific Name | Local Name | English Name | Uses |
|---|---|---|---|
| **Amaranthaceae** | | | |
| *Achyranthes aspera* (L.) Sw. | monga | prickly chaff flower | whole plant used for piles, skin eruptions, laxative |
| *Amaranthus gracilis* Desf. | chulai | wild amaranth | seeds and leaves are eaten like a vegetable |
| *A. spinosus* L. | goja | spiny amaranth | used as cattle fodder |
| *Celosia cristata* L. | sarai | cockscomb | ornamental herb |
| **Anacardiaceae** | | | |
| *Mangifera indica* L. | am | mango | domesticated fruit tree |
| **Annonaceae** | | | |
| *Polyalthia longifolia* Thw. | ashok | | ornamental tree |
| **Apiaceaeae** | | | |
| *Daucus carota* L. | gajar | carrots | root crop |
| **Apocynaceae** | | | |
| *Nerium indicum* Mill. | kaner, chandnis | oleander | leaves in decoction to kill skin parasites |
| *N. oleander* Blanco | kaner, chandnis | oleander | ornamental, latex poisonous |
| **Asclepiadaceae** | | | |
| *Calotropis procera* R. Br. | ak, akua, akuwa | swallow wort, milkweed | leaves used for fevers and dropsy; leaves smoked for asthma and coughs; roots used as toothpaste |
| *Dregea volubilis* E. Mey | | | |
| *Pergularia daemia* (Forsk.) Chiov. | utran, aaksan | | |
| **Asteraceae** | | | |
| *Blumea lacera* (Burm. f.) DC. | kakranda | thistle | dried plant smoked daily for treatment of piles |
| *Eclipta prostrata* (L.) Mant. | bhangra, bhringaraj | | used in ayurvedic medicine; head, teeth, skin disorders; hair tonic |
| *Launea nudicaulis* Hook. | gobi | | latex from roots |
| *Pulicaria crispa* Sch. Bip. | haldwa | | |
| *Vernonia cinerea* (L.) Less | sadodi | | roots anthelmintic, infusions of leaves for fever |
| *Xanthium strumarium* L. | bhangra, bichnu | burdock | weed |
| **Balsaminaceae** | | | |
| *Impatiens balsamina* L. | | impatiens | ornamental |
| **Bombacaceae** | | | |
| *Bombax malabaricum* L. | simalu | silk cotton tree | produces silk cotton used in upholstery |
| **Boraginaceae** | | | |
| *Cordia myxa* L. | laswora | | edible fruit, native medicine, wood for boat construction |
| *Heliotropium subulatum* (DC.) Hochst. | | | |
| **Brassicaceae** | | | |
| *Raphanus sativus* L. | muli | radishes | root crop |
| **Caesalpinaceae** | | | |
| *Cassia tora* L. | pawad, chocowar | foetid cassia | leaves for intestinal disorders, skin diseases |
| **Cannabinaceae** | | | |
| *Cannabis sativa* L. | bhang | hemp | leaves used as sedative, anodyne, wound dressing, pseudonarcotic; gonorrhea and malaria treatment |
| **Cannaceae** | | | |
| *Canna indica* L. | swet-surva-juya | canna | ornamental |
| **Capparaceae** | | | |
| *Capparis decidua* (Forsk.) Edgew. | kareel | caper | edible fruits pickled |
| *Cleome viscosa* L. | hulhul | | juice of leaves used for ear infections |
| **Casuarinaceae** | | | |
| *Casuarina equisetifolia* L. | vilayti, jhau | Australian pine | ornamental tree |
| **Chenopodiaceae** | | | |
| *Spinacia oleracea* L. | palak | spinach | domesticate |
| **Commelinaceae** | | | |
| *Commelina baskarlii* Vahl. | kana | | |
| **Convolvulaceae** | | | |
| *Ipomea purpurea* (L.) Roth | kali-lahara | morning glory | fruits used for dandruff |
| **Cucurbitaceae** | | | |
| *Benincasa hispida* (Thunb.) Cogn. | petha, rui petha | white gourd | edible fruits sold in market (escaped here) |
| *Citrullus calocynthis* (L.) Schrad. | falka teré | bitter apple | fruit a purgative, dried used for stomach problems |
| *Coccinia cordifolia* (L.) Cogn. | kundru, kanduri | | used as a hedge plant |
| *Cucurbita* sp. | petha | sweet squash | fruits edible |
| *Luffa acutangula* (L.) Roxb. | tori | luffa | fruit fibers used as a sponge substitute |
| **Cyperaceae** | | | |
| *Cyperus* sp. | | sedge | |
| **Euphorbiaceae** | | | |
| *Croton bonplandianum* Baill. | pani | croton | sap used for soap |
| *Euphorbia hirta* L. | thoar | spurge | eaten as herb, whole plant antiamoebic, anticancer, boils, ulcers, bronchitis |
| *Ricinus communis* L. | arand | castor bean | ornamental shrub |
| **Fabaceae** | | | |
| *Alhagi pseudalhagi* (Bieb.) Desv. | jawasa, bharbharra | | used during hot summer months to make "tatties" |
| *Crotolaria juncea* (L.) Dill | sanai | sunn hemp | stems a fiber source, flowers eaten |
| *Dalbergia sisoo* Roxb. | | tulipwood | planted for shade |
| *Derris indica* (Lamk.) S.S.R.Bennet | papuree | derris | fish and arrow poison |
| *Dolichos lablab* L. | sem | hyacinth bean | cultivated for its pods |
| *Indigofera cordifolia* Heyne | catara | | |
| *I. enneaphyla* L. | leel | | can serve as an efficient soil binder |
| *Rhynchosia minima* (L.) DC. | | | |

Table 1. Current Vegetation of the Mahtab Bagh and Vicinity (*continued*)

| Scientific Name | Local Name | English Name | Uses |
|---|---|---|---|
| **Fabaceae** (continued) | | | |
| *Tephrosia purpurea* (L.) Pers. | *jhojhru, pawad* | | pods used for pain and inflammation |
| *T. villosa* (L.) Pers. | | | leaf used for diabetes |
| *Vicia faba* L. | *bakla sem* | broad bean | pods eaten as a vegetable; used as a cover crop for fodder and silage |
| **Lamiaceae** | | | |
| *Leucas aspera* (Wild.) Spreng. | *bonphuk* | | roots for mad dog bite; leaves for nosebleed, constipation, stomach ache, fever and urinary problems |
| *L. urticaefolia* R. Br. | *goma* | | roots and leaves for stomach ache, fever, urinary problems |
| *Mentha* sp. | | mint | |
| *Ocimum americanum* L. | *tusla, tulsiband, jangli tulsa* | basil | ripe seeds soaked in water, used as an eyewash |
| *Peristrophe bicalyculata* Nees. | *missi* | | weed |
| **Lemnaceae** | | | |
| *Lemna* sp. | | duck weed | standing water plant |
| **Lythraceae** | | | |
| *Ammania baccifera* L. | *kala bangra* | | used for treating pain, fever, and ringworm |
| **Malvaceae** | | | |
| *Abutilon bidentatum* Hochst. | | | |
| *Sida acuta* Burm. | *bala* | | leaf juice for intestinal worms |
| *S. cordifolia* L. | *kharenti, kharaiti* | country mallow | contains ephedrine, juice used for rheumatism; whole plant treatment for piles |
| **Meliaceae** | | | |
| *Melia azadirachta* L. | *nim, neem* | margosa | bark, leaves, flowers, seeds, and oil used for food and medicine |
| **Mimosaceae** | | | |
| *Acacia* cf. *arabica* Willd. | *babool* | babul | |
| *Prosopis juliflora* DC. | *kabuli kikar* | Babul's tree, mesquite | gum source |
| **Moraceae** | | | |
| *Ficus benghalensis* L. | *bar* | banyan | roots for hair growth; leaves eaten as vegetable |
| *F. glomerata* Roxb. | *gular, oodumber* | clustered fig | fruit edible; dye from bark; root for dysentery |
| *F. religiosa* L. | *ahot* | sacred tree | fruit a laxative; bark for boils and gonorrhea |
| *Morus alba* L. | *toot* | mulberry | planted for fruits; leaves used as fodder |
| **Myrtaceae** | | | |
| *Callistemon lanceolatus* DC. | | bottle brush | ornament |
| *Eucalyptus tereticornis* Sm. | | eucalyptus | shade tree |
| *Psidium guajava* L. | *amrud* | guava | edible fruits |
| **Nyctaginaceae** | | | |
| *Boerhavia diffusa* L. | *catará, santhi* | | leaves and roots: blood purifier, cough, asthma, muscular and chest pains, piles, snake bites |
| **Palmae** | | | |
| *Phoenix sylvestris* Roxb. | *khajoor* | sugar palm | edible fruits |
| **Papaveraceae** | | | |
| *Argemone mexicana* L. | *bherband* | prickly poppy | juice a diuretic, foot for skin diseases |
| **Poaceae** | | | |
| *Aristida* sp. | | | |
| *Cenchrus ciliaris* L. | *anjhan* | goathead weed | |
| *Chloris barbata* (L.) Sw. | | | |
| *Cynodon dactylon* Pers. | *doob, neel-doorya* (Sanskrit) | Bermuda grass | used in ayurvedic medicine for blood impurities, skin disease and bile disorders |
| *Dactyloctenium aegyptium* (L.) Beauv. | *makra* | | used as a nutritious fodder |
| *Dichanthium annulatum* Stapf. | *zarga, barlu, apang* | | used as cattle fodder |
| *Digitaria* sp. | | | |
| *Eragrostis tremula* (Stend.) Hochst. | *dholphulio* | love grass | used as fodder |
| *Pennisetum glaucum* (L.) R. Br. | | pearl millet | grain crop |
| *P. thyphoideum* Rich. | *bajra* | ginger millet | grain crop |
| *Saccharum munjo* Roxb. | *phuse* | cane | leaves used for basketry, mats |
| *Sorghum nitidum* Pers. | | | |
| *Triticum aestivum* L. | *gehu* | wheat | grain crop |
| **Punicaceae** | | | |
| *Punica granatum* L. | *anar, dadim* | pomegranate | juice and fruits taken for dysentery |
| **Rhamnaceae** | | | |
| *Zizyphus jujuba* Lam. | *badri, boray* | jujube | infusion of leaves for conjunctivitis, edible fruits |
| **Scropulariaceae** | | | |
| *Kicksia ramosissima* (Wall.) Janchen | *haribel* | green creeper | |
| **Solanaceae** | | | |
| *Datura innoxia* Mill. | *dhatura, kanak, shwet dhattoor* | thorn apple | narcotic properties; poison affecting sympathetic nervous system; used in ayurvedic medicine |
| *Pedalium murex* L. | *vilayti gokru* | cow's hoof | used in medicine |
| *Physalis minima* L. | *papotan* | | edible fruits |
| *Solanum melongena* L. | *baingan, brinjal* | eggplant | domesticated crop |
| *Withania somnifera* (L.) Dunal | *asgand* | | roots used for joint pain and as a tonic for emaciated children |
| **Verbenaceae** | | | |
| *Lantana camara* L. | *soh-yang-khlieh* | | fruits used as fish bait |
| *Phyla nodiflora* (L.) Greene | *bukkan, jai-pippali, bakaubuti* | | diuretic, astringent, useful for vision |

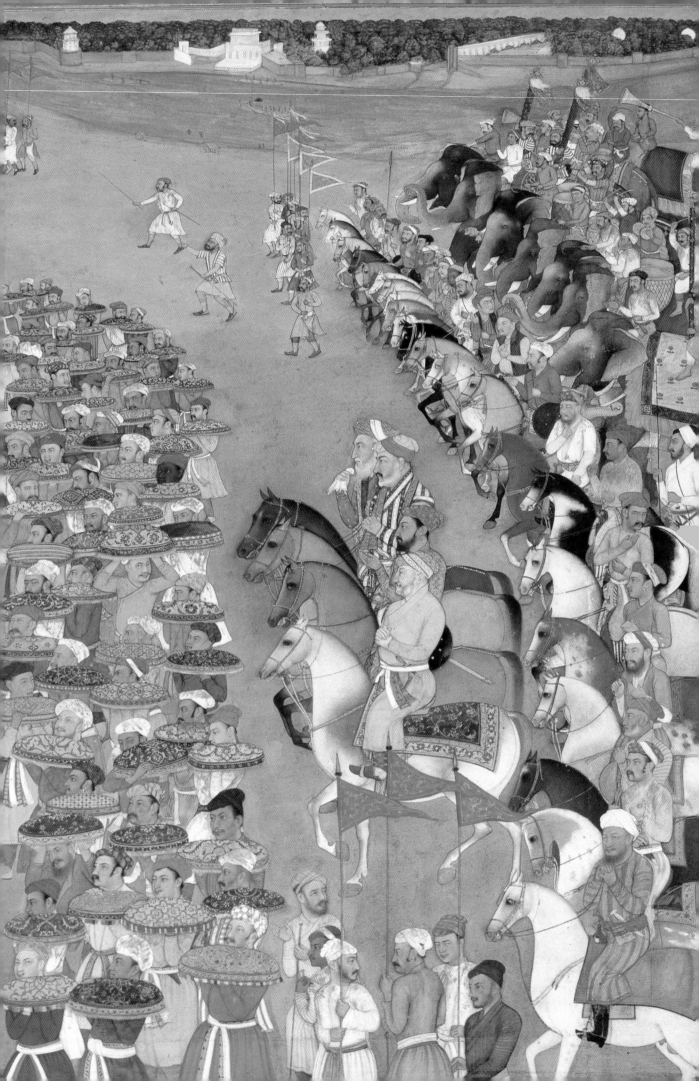

# Waterworks and Landscape Design in the Mahtab Bagh

*James L. Wescoat Jr.*

A sign for them is the land that is dead;

We do give it life, and produce grain therefrom, of which they do eat;

And we produce gardens with palm trees and vines;

And we do cause springs to gush forth therein.

KORAN 36:34, *inscription, outer west arch, Taj Mahal tomb*

FERRYING THE Yamuna River from the Taj Mahal to the Mahtab Bagh (Moonlight Garden), one wonders how moonlight danced in reflections on the river surface, in garden fountains, and through trees along the banks (figs. 1, 2). Even today, the daily lives of many Agra residents begin along the riverbanks—bathing, offering prayers, crossing to work. How, then, has this sacred river become so terribly depleted and polluted—almost dead—bubbling with anaerobic decomposition, drifting plastic bags, and refuse until monsoon rains release waters, sometimes floods, from upstream barrages? It is only then that fish splash, perhaps delighting in monsoon flows, perhaps struggling for oxygenated water at the river's surface. Extreme temperatures, fluctuating flows, purity, and pollution remind us that Mughal garden waterworks have played an important role refreshing plants and visitors alike (fig. 3).

Garden historians have celebrated the aesthetic, functional, and symbolic qualities of waterworks built during the Mughal dynasty (1526–1858). Understanding these waterworks requires a balance of poetics and practicality—a designer's as well as garden historian's perspective. We may begin by imagining tall marble fountains in a large, octagonal, lotus-foliated, pavilion-lined pool. Fountains accompany musicians and poets in the open sandstone pavilions while the Yamuna murmurs beyond. Water cascades over illuminated niches into a

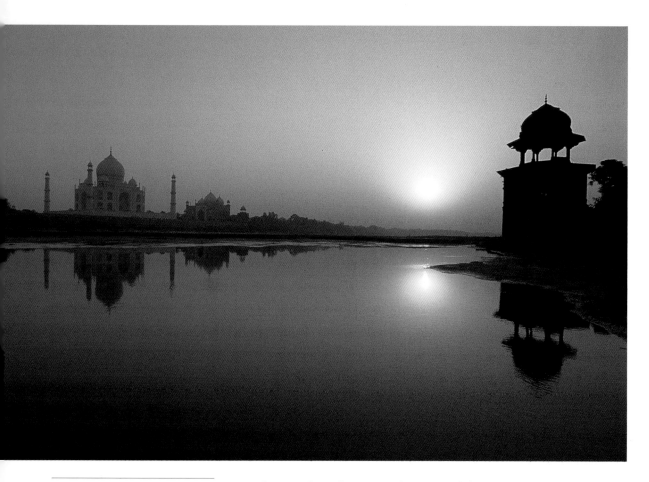

Figure 1. Sunset along the Agra riverfront
at the Taj Mahal, 1999. Photograph by
Neil Greentree

crisply carved sandstone pool. Irrigated fruit trees, flowering shrubs, and bulbs line the garden paths.

To refine these poetic images, we want to know how much water the plants, pools, and pavilions required; where those waters came from; and how drainage and floodwaters returned to the river. Evidence is scarce—scattered across texts, paintings, prints, and the site itself. To fill gaps, we may seek comparable water features at the Taj Mahal and other riverfront gardens in Agra[1]

Reconstructing these historic water systems, experiences, and meanings is the aim of this essay, which "follows the water"—from the requirements of the garden (water demand), to withdrawals from the Yamuna River and distribution through terracotta pipes (water supply), to fountains and pools (display and experience), and ultimately, its return to the Yamuna (drainage and flooding). A series of monumental inscriptions in the Taj Mahal, drawn from the Koran, parallels this sequence of water themes, sheds light on their meanings, and inspires the narrative that follows.

Page 58: *The Delivery of Presents for
Prince Dara-Shikoh's Wedding*, attributed
to Bishandas; India, ca. 1635. Opaque
watercolor and gold on paper; folio
120b: image area 33 x 23 cm. From the
*Padshahnama, Chronicle of the King of the
World*. Given by the Nawab of Oudh
to George III in 1799. The Royal
Collection © 2000, Her Majesty
Queen Elizabeth II. (See detail,
fig. 9, page 67.)

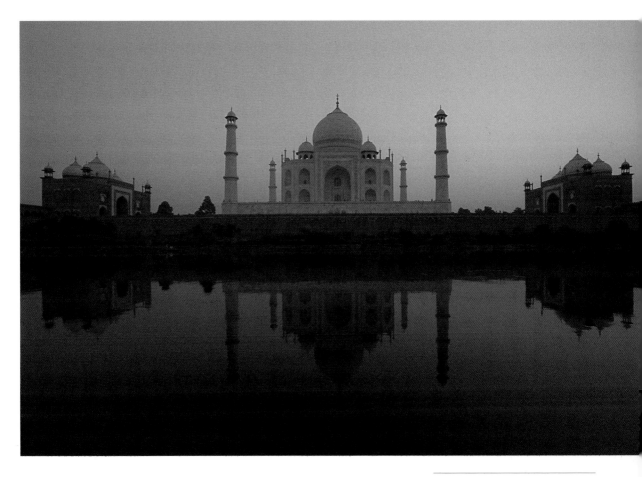

## WATER DEMAND

Figure 2. Reflections of the Taj Mahal in the Yamuna River, viewed from the Mahtab Bagh, 1999. Photograph by Neil Greentree

> They and their wives will be in groves of shade,
>
> reclining on raised couches;
>
> Fruit will be there for them;
>
> And they shall have whatever they call for.
>
> KORAN 36:55—57, *inscription, outer north arch, Taj Mahal*

The Mahtab Bagh encompasses about 9.7 hectares (24 acres), irrigated as well as rain fed, with elaborate waterworks along the Yamuna riverfront (fig. 4). Water was supplied from a gallery of wells, an aqueduct, and a cistern that drew water from the Yamuna at the southwest corner of the garden (see "Archaeology of the Garden"). Terracotta pipes delivered water from the tank to twenty-five fountains in a large octagonal pool, surrounded by lotus foliation common in Mughal pools. When the pool was full, water passed through a shallow channel at its northern end, over a sandstone lip that created a miniature waterfall in front of three rows of sandstone *chinikhana*s (small niches for oil lamps or flowers), into a small sandstone pool at their base (fig. 5). From that lower pool, the flow and fate of the water are a mystery. Aside from small drains into the garden, there are no clear links to axial channels of the sort one expects in a Mughal garden. In the center of the garden, however, there is

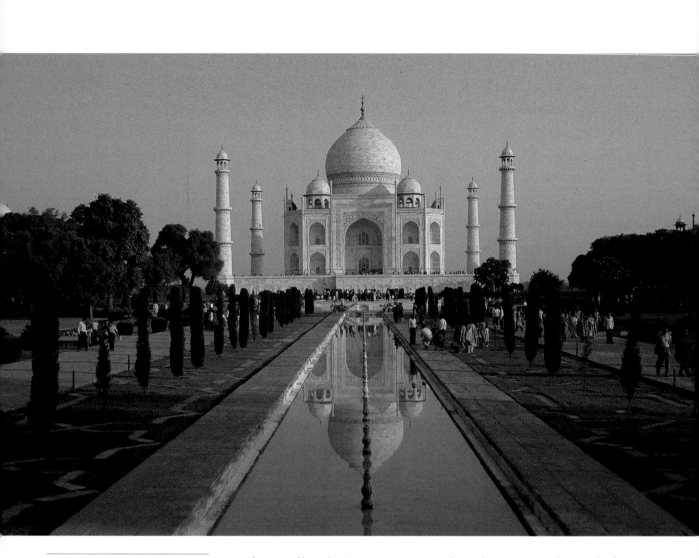

Figure 3. Pool and fountains at the
Taj Mahal, 1999. Photograph by Neil
Greentree

another small tank, 6.9 meters on a side and 1.4 meters deep, which
reinforces the view that this was a *charbagh* (fourfold garden), though no
crosswalks, water channels, or pipes have survived.[2] One small undated
brick-lined well stands near the garden axis, perhaps built to irrigate
plantings of the Mughal era or later. Drainage channels returned excess water from the
octagonal pool to the Yamuna. Floods scoured the riverfront, removing whatever landing
existed, depositing more than a meter of silt, and undercutting the southern end of the
octagonal pool and pavilions so deeply that they collapsed.

How much water did this garden require? To answer this question, we may begin with
the climate and hydrology of Agra. Although we have no paleoclimatic data for Agra, we can
construct a modern "water budget" that tells an interesting story about plant water needs
(fig. 6).[3] The water budget consists of four key variables: Precipitation (P); Potential
Evapotranspiration (PE)—the amount of water plants would need if fully irrigated; Actual
Evapotranspiration (AE, which equals PE−P)—the amount plants actually use; and Deficit
(D, which equals PE−AE)—the gap between plant water needs and actual use. These four
variables indicate that water supply and demand are balanced in January, after which rapidly

increasing water deficits and plant stress occur through June, when the monsoon breaks. Monsoon precipitation in July so greatly exceeds plant water needs (AE) that water runs off into ephemeral streams and back to the Yamuna River. After August, however, plants use up soil moisture, creating severe plant stress in October that subsides only during the winter months, when precipitation and evapotranspiration once again converge. Although native plants are adapted to these seasonal moisture deficits, exotics could suffer terribly unless provided with irrigation water in amounts and timings to match the deficits indicated on figure 6.

To irrigate the Mahtab Bagh plantings, waterworks would have had to deliver a volume of water equal to the depth of the annual water deficit times the area of the garden plantings (855 mm x 9.3 hectares, which equals approximately 79,600 cubic meters, or 64.5 "acre-feet," a common unit of irrigation measurement). This estimate of average garden water needs is complicated by several factors. Weather varies from year to year, especially in monsoon regions. Modern data indicate dramatic variation in seasonal and interannual rainfall in Agra.[4] A well-designed irrigation system accommodates dry years and drought periods as well as average conditions. Climate (defined as average weather conditions over thirty years) also varies over periods of decades and centuries. Although climatic conditions that prevailed when the garden was created varied in subsequent decades, it is difficult to distinguish climatic effects from human transformations of vegetation in the pollen record from the Mughal period onwards.[5]

The Yamuna River added two further complications. Monsoon flows recharged the alluvial aquifer, providing soil moisture for deeply

Figure 4. Overview of waterworks on the Mahtab Bagh waterfront.

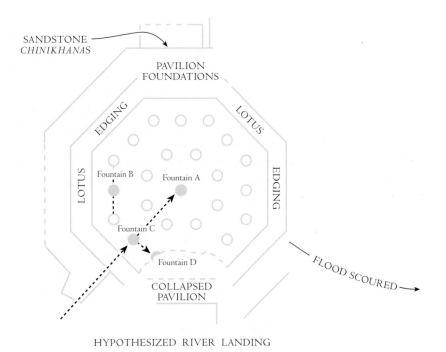

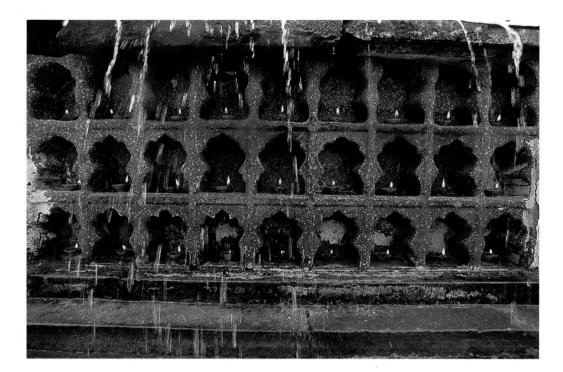

Figure 5. A miniature waterfall passed in front of these *chinikhanas*, or small niches for oil lamps or flowers, at the Mahtab Bagh, 1999. Photograph by Neil Greentree

rooted trees along the riverbank. But garden walls extended several meters below the surface blocking some of those subsurface flows. Flood flows penetrated garden walls, recharging soil moisture but also depositing sediments (primarily sand) that harmed garden plantings at least over the short term.

Although flooding was a perennial problem, the Yamuna River channel is remarkably stable at Agra, accounting for the survival of riverfront garden pavilions and towers. In Delhi, the second Mughal ruler, Humayun, is buried in a tomb-garden that was originally on the riverfront but now lies far from the modern channel. In Lahore, the Ravi River flows a kilometer west from its original channel near Lahore Fort and encircles the *baradari* (open pavilion) garden of Prince Kamran (brother of Humayun, died 1556) that once stood on the opposite bank.[6] Only Agra retains the broad traces of Mughal riverfront design.

In addition to its plantings, Mahtab Bagh had extensive water features. To estimate their water demand, we may calculate the volume of water needed to fill and run the features at any moment in time. Figure 7 indicates what can be roughly estimated from extant features.

While plantings may have consumed up to 64.5 acre-feet, each filling of the waterworks required 1.5 acre-feet (or 2 percent of the total). Some of the water in pools may have come from monsoon precipitation, but much more water would have evaporated. To actually "run" the fountains, kitchen, and toilets, additional water was needed. How much water depends on the frequency, nature, and duration of garden use—about which we know very little. If intermittently used, waterworks may have had one refilling (i.e., 3 acre-feet); if seasonally or annually used, two to three refillings (up to 6 acre-feet).

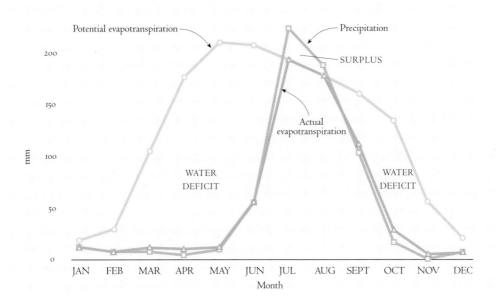

Agra Water Balance

Landscape Architectural Water Demand

| Feature | Estimated Volume (m³) | Speculated Volume (m³)* |
|---|---|---|
| Octagonal pool | 1510 | — |
| Fountain network and jets | 11 | — |
| Cascade and small pools | 6 | — |
| Central water tank | 45 | — |
| Aqueduct | 34 | — |
| Cistern | 8 | — |
| Hypothesized water axes | | 60 |
| Other/unknown | | |
| (e.g., baths, toilets, drains, and kitchen ) +10% | | 170 |
| Subtotal Waterworks | — | 1840 m³ |
| (Equals approx. 1.5 acre-feet [AF]) | | (1.5 AF) |
| Plant water requirements subtotal | | 79,600 m³ |
| | | (64.5 AF) |
| Total (assuming only one filling of waterworks) | | 81,440 m³ |
| | | (~66.0 AF) |

*Crude estimates rounded to the nearest 10 m³ . Based on 1998 field research.

A fully irrigated garden with continuous fountain displays might have required 70 acre-feet per year. This figure corresponds with the amount of water used by approximately 70 modern suburban households of four in the United States—or 200 urban households in Uttar Pradesh! It seems unlikely that the full irrigation requirement was supplied to a garden rarely visited by Shahjahan and only occasionally by other members of the royal family. Deficit irrigation is a common practice. But it also seems unlikely that the surviving aqueduct and cistern could have supplied even a major fraction of the

Figure 6. Water balance diagram for modern Agra.

Figure 7. Landscape architectural water demand estimated from surface data at the Mahtab Bagh.

water needed. They could certainly have kept the fountains running, and perhaps have filled the pool once or twice (a volume 36 times that of the aqueduct and cistern). But the aqueduct and cistern would have to be filled nineteen hundred additional times to irrigate the garden. Two thousand fillings per year is a lot for such a small structure, suggesting that there were additional sources of supply or other scenarios of garden water use. Before drawing any conclusions, it is useful to take a closer look at the waterworks.

## WATER SUPPLY: LIFTING, STORAGE, AND DISTRIBUTION

> Say: "What think ye? If in the morning your streams should have sunk into the earth, who then shall give you clear and running water?"
>
> KORAN 67:30, *inscription, inside southeast arch, Taj Mahal*

The Mahtab Bagh fountains were supplied from a gallery of shallow wells along the Yamuna River. In many gardens river diversions and wells operated independently, but they were directly linked at the Mahtab Bagh. An eighteenth-century map (see "Archaeology of the Garden," fig. 1) depicts a line of four wells, while A. C. L. Carlleyle, in a report for Agra in 1871–72 mentions nine.[7] Only one was visible in 1996, but none in 1998, when the well appears to have been covered by a thin layer of earth in the local garden. These brick-lined wells offered two advantages over direct diversions from the river: they provided a fixed point of access, even when river levels fluctuated, and they filtered sediments from the river water. Riverfront wells served as desilting basins as well as water sources.

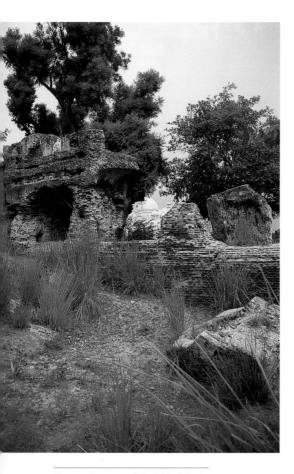

The original depth of these wells is unknown. Also unknown are the means of lifting water from them into the short aqueduct. Water-lifting devices at the Taj Mahal and the tomb-garden of I'timauddawla (died 1621; grandfather of Mumtaz Mahal and prime minister under the third Mughal ruler, Jahangir) involved *pur*s (leather buckets lifted by ropes), pulled by bullocks walking down an inclined slope (figs. 8, 9).[8] Although Babur criticized these devices as unsanitary and advocated the Persian wheel (*rehant*—a chain of ceramic pots lifted over a gear-driven wheel turned by bullocks), the latter do not seem to have been used in the Taj Mahal-Mahtab Bagh complex.

Figure 8. Remnants of the Mahtab Bagh aqueduct, 1999. Photograph by James L. Wescoat

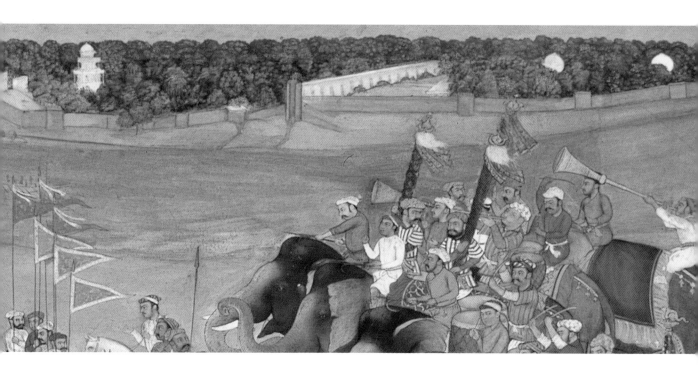

## Water Supply System — Mahtab Bagh

### Plan View

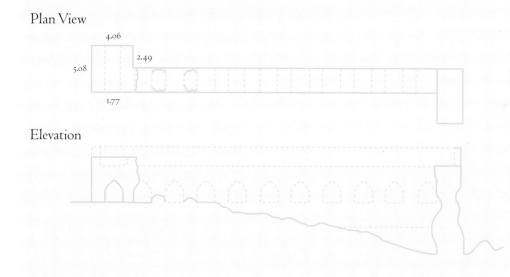

### Elevation

Figure 9. Detail, *The Delivery of Presents for Prince Dara-Shikoh's Wedding.* The background of this processional scene, shown in full on page 58, depicts the walled garden enclosures, buildings, waterworks, and water lifting devices along the northern banks of the Yamuna River. The long structure to the right is an aqueduct. These structures resemble the Mahtab Bagh.

Figure 10. North elevation of the Mahtab Bagh aqueduct, reconstructed from extant piers and aqueduct fragments.

Figure 11. Ruins of cistern, Mahtab Bagh, 1999. Photograph by Neil Greentree

An aqueduct carried water from the wells to an elevated cistern. The five extant piers and scattered fragments of water channels make it possible to reconstruct the design of the original aqueduct (fig. 10). It traveled a length of 35 meters over a series of twelve arches. The water channel was less than one meter deep. It widened over each arch, perhaps to receive water from the wells below and to carry a larger volume of water. A nearby aqueduct is depicted in the background of a work from the *Padshahnama* painted circa 1635[9] (see fig. 9).

The aqueduct discharged water into a small water cistern (fig. 11). A plastered slot on the northern side of the water tank remains something of a mystery. It may have carried water along the garden wall toward the central water tank or other water uses in the middle of the garden. On the eastern side of the cistern, four terracotta pipes drop vertically to supply the garden fountains. The pipes did not travel directly east toward the fountains, a possibility ruled out by a test pit on the western edge of the octagonal pool in 1998 that revealed no evidence of terracotta pipe at a depth of two meters. Part of the water distribution system was discerned by cleaning out previously excavated fountain pits (fig. 12), which revealed that the central fountain A was fed by a single terracotta pipe from fountain C, which was fed in turn by a water supply line from the southwest.[10] Not all pits were connected to each other. Fountains B and D were connected only to their nearest neighbors on the outer ring. Supply to the middle ring remains a mystery, but the piping pattern suggests that the surviving cistern may not have served the entire fountain network.

The fountain pits are 1.6 meters deep and roughly 0.6 meters wide, set in a layered

foundation of concrete, sandstone, and brick (fig. 13). They were fed by terracotta pipes, 13 centimeters in diameter, that discharged water to a plaster-lined bowl at the base of the fountain. In the Taj Mahal such bowls contained brass pots for pressure control. Fountain fragments excavated by the Archaeological Survey of India (ASI) and removed to a Taj Mahal storehouse indicate that white ribbed marble fountain shafts were seated on a base of red sandstone blocks (fig. 14).

Evidence from the water budget analysis, fountain pits, and *The Taj Mahal, Agra,* an eighteenth-century print by William and Thomas Daniell (see p. 32) suggests that there may have been a second aqueduct and cistern near the tower in the southeast corner of the garden.[11] Although no cartographic source indicates waterworks in that location, the area would have been subject to severe eddy scouring and erosion on the downstream side of the garden walls.

Figure 12. Fountain pit at the Mahtab Bagh, 1999. Photograph by Neil Greentree

## WATER DISPLAY AND EXPERIENCE

But the righteous shall drink of a cup mixed with camphor—A Fountain whereat the devotees of God do drink, causing it to flow forth in abundance.

KORAN 76:5–6, *inscription, inside western arch, Taj Mahal*

The functional waterworks described above ultimately delivered water to an aesthetic sequence of fountains and pools. In the heat of May, the Mahtab Bagh established a cool microclimate through evaporation from the pools, cascades, and fountain jets. The *Padshahnama* and other images suggest that nighttime use may have been common, with fireworks illuminating the riverbanks and reflecting in the river.

The octagonal pool offered partial reflections of the Taj Mahal, as the Yamuna River does today during low flows in May (fig. 15). But just as the Yamuna produces fissured reflections during the monsoon, so too would fountains in the octagonal pool have dashed images of the Taj Mahal into a thousand dancing fragments. Those twenty-five monumental fountains presented a dramatic foreground to the Taj Mahal, which was visible above and through the *bangla* pavilion on the north side of the octagonal pool. On moonlit nights, reflected light from the Taj would have gently illuminated the Mahtab Bagh fountains, pool, and pavilions. The broad octagonal terrace would have been circumambulated, offering views of the fountains from all sides.

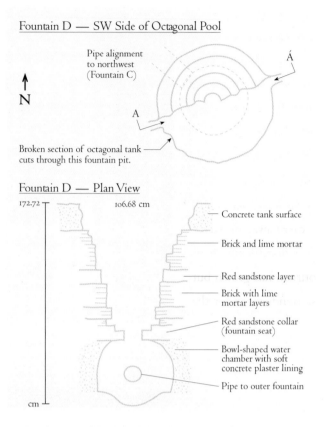

Fountain D — SW Side of Octagonal Pool

Pipe alignment
to northwest
(Fountain C)

Á

N

A

A

Broken section of octagonal tank
cuts through this fountain pit.

Fountain D — Plan View

172.72      106.68 cm

— Concrete tank surface

— Brick and lime mortar

— Red sandstone layer

— Brick with lime
mortar layers

— Red sandstone collar
(fountain seat)

— Bowl-shaped water
chamber with soft
concrete plaster lining

— Pipe to outer fountain

cm

Fountain D — Section A–Á

Figure 13. Cross section of the Mahtab
Bagh fountain pit "D."

Although the octagonal pool roughly parallels the plan of the Taj Mahal tomb, it differs in width and form, as the Mahtab Bagh has a regular octagon shape while the Taj Mahal is a "Baghdadi octagon" whose chamfered corners are shorter than its sides. There may have been historical associations between the Mahtab Bagh pool and an earlier octagonal pool built by Babur on the left bank of the river (see "Reflections of Paradise"). Gulbadan Begum (died 1603, sister of Humayun and author of the *Humayunnama*) wrote of an octagonal tank in Humayun's Mystic House that doused unsuspecting young people at a feast, which reminds one of the *giocchi d'acqua* in Italian gardens at that time, and which is just one example of the complex aesthetic psychology of Mughal waterworks.[12] Humayun's mosque is the nearest Mughal monument to the Mahtab Bagh, and the octagonal pool may have alluded to these earlier tanks built by Babur and Humayun.

## DRAINAGE AND FLOOD WATERS

> And a Sign for them is that We bore their own kind in the loaded Ark;
>
> And We created for them similar vessels whereon they ride.
>
> If it were our will we could drown them,
>
> Then there would be no one to help them.
>
> KORAN 36:43, *inscription, outer west arch, Taj Mahal tomb*

In December 1652, Prince Aurangzeb wrote to his father Shahjahan that the Taj Mahal dome was leaking and described what was done about it. He wrote that, "The Mahtab Garden was completely inundated, and therefore it has lost its charm, but soon it will regain its verdancy. The octagonal pool and the pavilion *(bangla)* around it are in splendid condition. It is surprising to hear that the waters of the Jumna have overflowed their banks because at present the river is moving back to its old course and is about to regain it[13] (see "Letter from Aurangzeb to Shahjahan," p. 28). Although Aurangzeb was later known as a "pious" ruler,

his letter displays the ordinary concerns of a property owner affected by flood rather than the signs mentioned on the inscription from the Koran above.

Prior to large-scale water diversions in the twentieth-century, flooding was a frequent phenomenon. But Agra is distinct among cities along the plains for the stability of its river channel and the solidity of its riverfront garden walls and piers that enabled the survival of riverfront gardens.[14] Eventually, the Mahtab Bagh was so frequently flooded that its pavilions were ruined, plantings swept away, and a massive tank collapsed. Drains could not carry away its excess waters. Floods lessened during this century, but flood losses have increased due to urbanization in the region. Tourism has grown but so have environmental problems. What do these trends mean for the future?

## THE MEANINGS OF WATER

> And mingled therewith shall be the waters of Tasnim;
> A Fountain whereat do drink those nearest unto God.
>
> KORAN 83:27–28, *inscription, east side of the cenotaph, Mumtaz Mahal*

Figure 14. Marble fountain shaft from the Mahtab Bagh, stored in ASI building at the Taj Mahal, 1998. Photograph by James L. Wescoat

Beyond aesthetic experience, did the Mahtab Bagh waterworks have any special meaning? Mughal waterworks often connoted the Four Rivers of Paradise, but the Mahtab Bagh had a single prominent pool and channel. The fountains of paradise—Tasnim and Salsabil—are mentioned in inscriptions at the Taj Mahal but are not apparent in extant water features at the Mahtab Bagh.[15] The art historian Wayne Begley's mystical interpretation of the Taj Mahal, inspired by images from the Sufi cosmologist Ibn al-Arabi (died 1240), might be extended to the Mahtab Bagh, though Elizabeth Moynihan suggests the Yamuna River separates the pleasure garden of the living from the tomb-garden of the deceased (see "Reflections of Paradise").[16] The architectural historian Ebba Koch chides Begley for straying too far into Islamic cosmology when "All the evidence suggests rather that the aim of the planners was to perfect the earlier tradition of the waterfront garden, and then to enlarge it to a scale beyond the reach of ordinary mortals in order to create an ideal paradisical garden for the deceased."[17] But these two interpretations are not incompatible.

Another speculative possibility involves Shahjahan's frequent allusions to King Solomon. In one account, Solomon invites Queen Bilkis to enter the palace. She mistakes the polished floor for water and raises her skirt, baring her legs. When Solomon reveals the

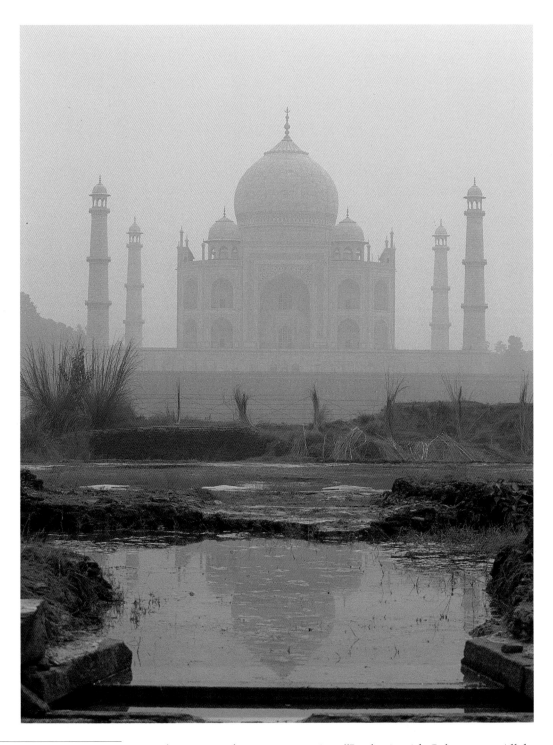

Figure 15. Reflections of the Taj Mahal in the Mahtab Bagh pool, 1999. Photograph by Neil Greentree

actual situation, she converts, saying, "I submit with Solomon to Allah, Lord of the Creation" (Koran 27:44, trans. Abdullah Yusuf Ali). Reflections of Taj Mahal minarets in the Yamuna and white marble fountains in the Mahtab Bagh pool repeat the common theme of "crossing over" in each of these interpretations.

Recent research has underscored the importance of patronage by women in Timurid art and architecture.[18] Ebba Koch has shown that the Ram Bagh, a garden upstream of

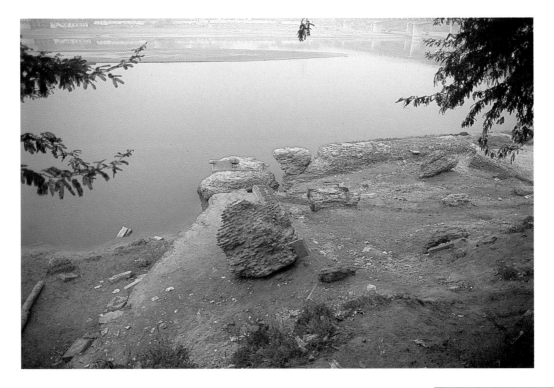

Mahtab Bagh, was shaped by Queen Nurjahan (died 1645, wife of the fourth Mughal ruler Jahangir) and that Zahra Bagh, another upstream garden, was built by Princess Jahanara (died 1681, daughter of Mumtaz

Figure 16. Riverfront landing at the Zahra Bagh, Agra, 1998. Photograph by James L. Wescoat

Mahal and Shahjahan).[19] This pattern of garden patronage raises questions about Jahanara's possible role at Mahtab Bagh as well. From a purely material standpoint, Mahtab Bagh had a riverfront landing like the Zahra Bagh (fig. 16). From an experiential standpoint, royal women spent far more time in Agra than did Shahjahan, at least until his confinement in the Red Fort. As her mother's tomb and the first monumental tomb built for a Mughal queen, the Taj Mahal may have had special significance for Jahanara and other women of the royal family.

POETICS AND PRACTICALITY IN MUGHAL WATERWORKS

> It is We that sent Sechina [tranquility] into the hearts of the believers,
> that they may add faith to their faith for to God belong the hosts of the heavens
> and the earth;
> and God is full of knowledge and Wisdom.
> That He may admit the believers, men and women alike,
> to the gardens of Paradise, beneath which rivers flow,
> to dwell therein forever.
>
> KORAN 48:4−5, *inscription, inner southeastern arch, Taj Mahal*

Figure 17. Man pouring a drink of water at the Mahtab Bagh, 1998. Photograph by James L. Wescoat

Waterworks are an essential feature of Mughal gardens. Understanding them involves a mix of poetics and practicality. Much of this essay has focused on the latter, asking how much water was needed, how was it supplied, and how did the system work? These themes require an appreciation of climate and hydrology that the Mughals did not have at the time of Babur's invasion but that they quickly learned and adapted at sites like the Mahtab Bagh. Success could not be assumed or assured. The seventeenth-century European traveler William Finch attributed abandonment of Fatehpur Sikri, the Mughal ceremonial capital constructed by Akbar just forty kilometers west of Agra, to its insufficient water supply. Although he may have exaggerated the significance of water problems in Akbar's decision to move to Lahore, water problems may nevertheless have been severe.[20]

Research on Mughal waterworks today requires a similar balance of poetics and practicality. The Taj Mahal and its environs are a primary tourist destination in India. Tourists are drawn by stories of romance but repelled by environmental degradation. The Supreme Court of India has established a regional protected area, known as the Taj Trapezium, and a series of decrees addressing industrial pollution, land use planning, removal of shopkeepers

from the Taj forecourt, and establishment of a greenbelt that encompasses part of the Mahtab Bagh site. The most recent Supreme Court case *M. C. Mehta v. Union of India* (December 31, 1997) requires 292 industries to convert to natural gas power within a twelve-month period or shut down and compensate laid-off workers. Concurrently, the government of India has launched a Yamuna Action Plan, with financial support from the Japanese government. This plan seeks to increase the quantity and reliability of water delivered to Agra, maintain minimum flows and water quality standards in the Yamuna, and reduce untreated waste disposal from upstream cities and industries. Untreated waste is often said to be the only water that reaches the river at Agra in the low-flow months of May and June.

But have these Supreme Court mandates accelerated beyond our understanding of the historical and modern landscape? Proposals to build barrages to create flatwater reaches in Agra for tourism purposes, for example, raise numerous ecological as well as economic issues. In 1998, the Archaeological Survey of India Horticulture Department sank tube wells to irrigate extensive new plantings "in the Mughal style."

The practical questions are: How much water is needed? At what rates and times? To support what types of plantings? And with what effects on surrounding village water supplies? (See fig. 17.) The poetic questions are: How was the garden actually experienced in Mughal times? What beauty and meanings does it have for nearby villagers today?[21] What new beauty and meanings might be envisioned and realized there tomorrow? Perhaps Mahtab Bagh is a place where the poetics and practicality of Mughal waterworks could flow together, uniting the peoples and places of Agra with visitors from around the world. ◧

## NOTES

My first research on Mughal gardens in 1984 focused on waterfront gardens in Agra. Fellowships from Dumbarton Oaks and the Arthur M. Sackler Gallery, and encouragement from Milo C. Beach and Francine Berkowitz, helped me get started, and Elizabeth B. Moynihan helped me to return to Agra on the Mahtab Bagh project in 1998 and 1999.

All translations of inscriptions from the Koran are from Wayne E. Begley and Ziyauddin A. Desai, eds., *Taj Mahal, The Illumined Tomb—An Anthology of Seventeenth Century Mughal and European Documentary Sources* (Cambridge, Mass.: Aga Khan Program for Islamic Architecture, 1989), which follow the translations of Abdullah Yusuf Ali and Arthur J. Arberry.

1. Ebba Koch, "The Mughal Waterfront Garden," in *Gardens in the Time of the Great Muslim Empires: Theory and Design,* ed. Attilio Petruccioli (Leiden: E. J. Brill, 1997), pp. 140–60; Koch, "Tadj Mahall," *Encyclopedia of Islam,* new ed. (Leiden: E. J. Brill, 1998), 10:58 60.

2. For discussion of the *charbagh* concept, see Elizabeth B. Moynihan, *Paradise as a Garden in Persia and Mughal India* (New York: George Braziller, 1979); and James L. Wescoat Jr. and Joachim Wolschke-Bulmahn, eds. *Mughal Gardens: Sources, Places, Representations, and Prospects* (Washington, D.C.: Dumbarton Oaks, Research Library and Collection, 1996).

3. Cort J. Willmott et al., "Average Monthly and Annual Surface Air Temperature and Precipitation Data for the World," *Publications in Climatology* 34, no. 104 (Agra) (Centerton, N.J.: Laboratory of Climatology, 1981); C. W. Thornthwaite Associates, *Average Climatic Water Balance Data of the Continents,* part 2. *Asia (Excluding U.S.S.R.)* (Centerton, N.J.: Laboratory of Climatology, 1963), p. 110.

4. Dennis J. Shea and N. A. Sontakke, *The Annual Cycle of Precipitation over the Indian Subcontinent: Daily, Monthly, and Seasonal Statistics,* NCAR/TN-401+STR (Boulder, Colo.: National Center for Atmospheric Research, Climate and Global Dynamics Division, 1995).

5. C. Sharma, "Recent Pollen Spectra from Garhwal Himalaya (India)," *Geophytology* 15, no. 1 (1985): 87–97.

6. James L. Wescoat Jr., Michael Brand, and M. Naeem Mir, "The Shahdara Gardens of Lahore: Site Documentation and Spatial Analysis," *Pakistan Archaeology* 25 (1993): 333–66.

7. Map of Agra, 18th century, City Palace Museum of Jaipur. See Chandramani Singh, "Early 18th Century City Maps on Cloth," in *Facets of Indian Art,* ed. R. Skelton et al. (London: Victoria and Albert Museum, 1986), pp. 185–92. See also A. C. L. Carlleyle, *Agra: Report for the Year 1871–1872,* vol 4. (Reprint Varanasi: Indological Book House, 1966).

8. Ram Nath, *Agra and Its Monuments* (Agra: Historical Research Documentation Programme, 1997), pp. 122–24.

9. Milo Cleveland Beach, Ebba Koch, and Wheeler M. Thackston, *King of the World: The Padshahnama, An Imperial Mughal Manuscript from the Royal Library, Windsor Castle* (London: Azimuth Editions; Washington, D.C.: Arthur M. Sackler Gallery, 1997), p. 63.

10. There have been few empirical or archaeological studies of Mughal fountains. The principal one to date occurred at Shalamar Garden, Lahore, by Syed Dildar Hussain, Nurul Mustafa, and Naeem Ahmad Khan, *Leakage Investigation at Shalamar Garden, Lahore Using Radioisotopes* (Rawalpindi: Pakistan Institute of Nuclear Science and Technology, 1979); see also Ihsan H. Nadiem, "The Hydraulics of Shalamar Garden," *Pakistan History and Culture* 34 (1986): 1–13.

11. "The Taje Mahel, Agra," originally published as a colored aquatint (53.3 x 87.6 cm) in *Views of the Taje Mahel at the City of Agra in Hindoostan taken in 1789,* reprinted in Mildred Archer, *Early Views of India: The Picturesque Journeys of Thomas and William Daniell, 1786–1794* (New York: Thames and Hudson, 1980), fig. 29, pp. 68–69.

12. James L. Wescoat Jr., "Gardens of Invention and Exile: The Precarious Context of Mughal Garden Design During the Reign of Humayun (1530–1556)," *Journal of Garden History* 10 (1990): 106–16. And for related discussions of Mughal waterworks, see Wescoat "Early Water Systems in Mughal India," *Environmental Design: Journal of the Islamic Environmental Design Research Centre,* 2 (1985): 50–57; Wescoat, "L'acqua nei giardini islamici: Religione, rappresentazione e realta" (Water in Islamic gardens: Religion, representation, and reality), in *Il Giardino Islamico: Architettura, natura, paesaggio,* ed. Attilio Petruccioli (Milan: Electa, 1994), pp. 109–126; Wescoat "Waterworks and Culture in Metropolitan Lahore," *Asian Art and Culture* 8, no. 2 (Spring/Summer 1995): 21–36.

13. For a fuller treatment of floods and other hazards see C. M. Agarwal, *Natural Calamities and the Great Mughals* (Bodh Gaya: Kanchan Publications, 1983).

76

14. Koch, "Mughal Waterfront Garden," pp. 140–60.

15. Yasser Tabbaa, "The Medieval Islamic Garden: Typology and Hydraulics," in *Garden History: Issues, Approaches, Methods*, ed. John Dixon Hunt (Washington, D.C.: Dumbarton Oaks, 1989), pp. 303–29.

16. Wayne E. Begley, "The Myth of the Taj Mahal and a New Theory of Its Symbolic Meaning," *Art Bulletin* 61 (1979): 7–37; Begley "The Garden of the Taj Mahal: A Case Study of Mughal Architectural Planning and Symbolism," in *Mughal Gardens*, ed. Wescoat and Wolschke-Bulmahn, pp. 213–31.

17. Koch, "Mughal Waterfront Garden," p. 144.

18. Lisa Golombek, "The Gardens of Timur: New Perspectives," *Muqarnas* 12 (1995): 137–47; Golombek, "Timur's Gardens: The Feminine Perspective," in *The Mughal Garden: Interpretation, Conservation and Implications*, ed. Mahmood Hussain, Abdul Rehman, and James L. Wescoat Jr. (Lahore: Ferozsons Ltd., 1996), pp. 29–36; Roya Marefat, "Timurid Women: Patronage and Power," *Asian Art* 6, no. 2 (Spring 1993): 28–49; Ellison Findly, *Nur Jahan: Empress of Mughal India* (Oxford: Oxford University Press, 1993).

19. Ebba Koch, "The Zahara Bagh (Bagh-i-Jahanara) at Agra," *Journal of the Islamic Environmental Design Research Center:* 2 (1986): 30–3; Koch, "Notes on the Painted and Sculptured Decoration of Nur Jahan's Pavilions in the Ram Bagh (Bagh-i Nur Afshan)," in *Facets of Indian Art*, ed. Skelton et al., pp. 51–65.

20. Michael Brand and Glenn D. Lowry, *Fatehpur-Sikri: A Sourcebook* (Cambridge, Mass.: Aga Khan Program in Islamic Architecture, 1985), pp. 213–4. See also Attilio Petruccioli, *La Citta' del Sole e Delle Acque: Fathpur Sikri* (Rome: Carucci Editore, 1988), pp. 54–59.

21. J. S. Bhandari, "An Ethnographic Study of Nagla Devjit, Nagla Kachchpura, and Garhi Chandni," unpublished report for the Agra Heritage Project (Delhi: Department of Anthropology, University of Delhi, 1993).

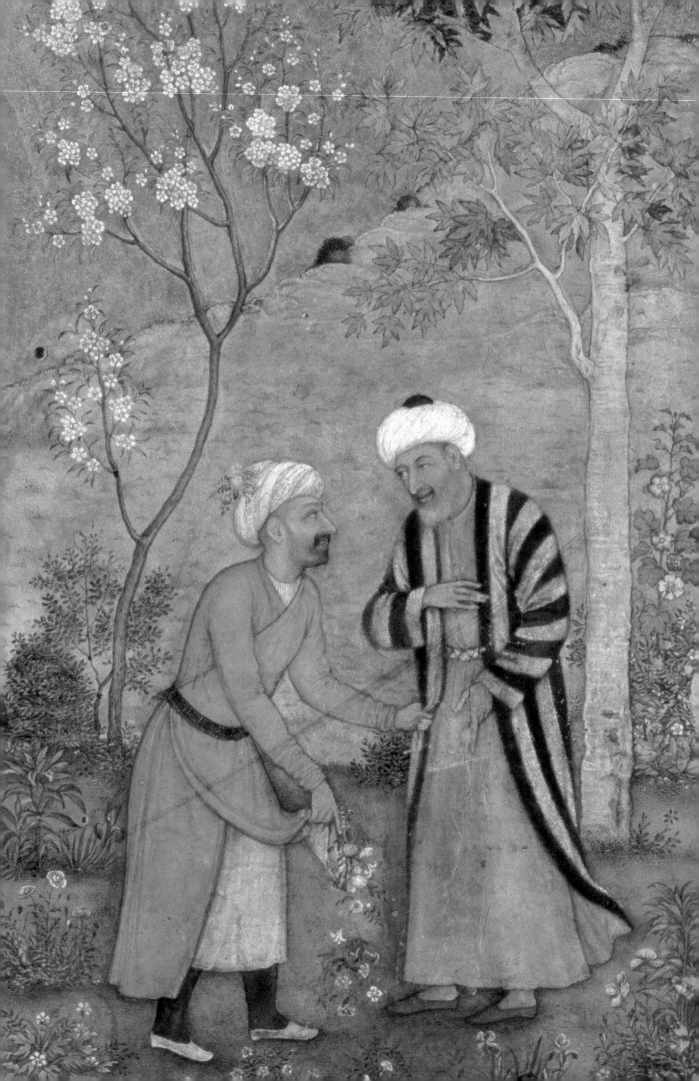

# Archaeology of the Garden

*John M. Fritz and George Michell*

In DECEMBER 1652, Aurangzeb, on an inspection tour of the building works at the Taj Mahal, noted that the Mahtab Bagh, on the opposite bank, had been badly damaged by floods. This observation, in a letter to his father Shahjahan (see "Letter from Aurangzeb to Shahjahan," p. 28), reminds us of the threat the Yamuna River posed to the garden soon after it was finished. In fact, the Mahtab Bagh continued to be inundated through the years, and many of its architectural features have been washed away or are now lost to sight under accumulated layers of silt and sand. Nor has the river been the most destructive force: local villagers have periodically pillaged the garden for its red sandstone blocks and brickwork. Except for one corner tower, the surviving structures are reduced to their masonry foundations.

Despite its dilapidated appearance, the Mahtab Bagh can be studied and its plan reconstructed. Our examination of the decaying structures and the results of the recent excavations permit us to determine the overall layout of the garden and the forms of its most important architectural components. Our observations reveal a carefully planned complex, axially and dimensionally coordinated with the Taj Mahal. As far as we can judge, the Mahtab Bagh was part of a scheme unknown in any other Mughal garden. Its arrangement underscores its unique purpose as a pleasure garden from which the Mughal nobility could gaze at the Taj. Two views of the mausoleum would have been possible from the Mahtab Bagh: one of the actual building itself, soaring sublimely above the riverfront wall of the garden; the other of its inverted reflection in a large octagonal pool that formed the centerpiece of a raised terrace. Thus visitors were offered an aesthetic experience that combined a real and a reflected image visually uniting the garden and tomb in a scheme of truly imperial proportions.

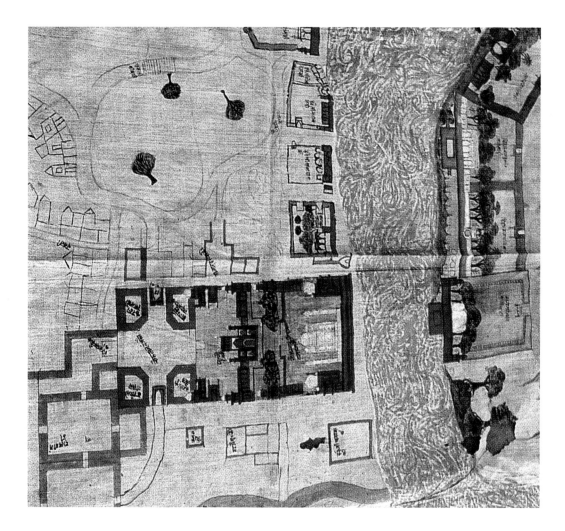

## OLD MAPS OF THE MAHTAB BAGH

Before examining the surviving architectural components of the Mahtab Bagh in some detail, we should first like to refer to some early maps of the garden. Though these anonymous works were intended as visual mementos of Agra and the Taj rather than scientific documents, they are nevertheless of interest for the wealth of detail they contain. Two watercolor maps executed on cloth are particularly significant: one is in the Maharaja Sawai Man Singh II Museum in Jaipur; the other is in the Taj Museum in Agra. The Jaipur map (fig. 1, above) which dates from the first half of the eighteenth century, shows the plan of Agra city, correctly locating the Mahtab Bagh on the north bank of the Yamuna, directly opposite the Taj. The garden occupies a rectangular area, slightly longer in the north-south direction, enclosed on three sides by pale gray bands indicating peripheral walls. A similarly colored zone projecting into the garden in the middle of the north side may represent a gateway. The riverside boundary of the garden on the south is a bright red band, doubtless intended to depict a red sandstone wall. A landing platform depicted with the same color projects southward from this wall into

Page 78: Detail, *Sa'di in the Rose Garden, from a manuscript of the Gulistan* by Sa'di. By Govardhan, India, ca. 1645. Opaque watercolor, ink, and gold on paper; without border: 12.9 x 6.7 cm. Freer Gallery of Art, gift of the Art and History Trust in honor of Ezzat-Malek Soudavar, F1998.5.6a

the river. A pavilion with triple domes or vaults is shown on top of the red band, as if elevated on the wall. The interior of the pavilion is filled with white, while the columns and domes or vaults above are deep green-brown. Except for a pale brown tone suggesting sand, the garden is otherwise empty.[1]

The Taj Museum map below (fig. 2), probably painted in the early decades of the nineteenth century, is differently conceived. It presents a planimetric view of the Taj complex, extended northward to include the Mahtab Bagh. The garden's riverfront wall is represented by a broad red band with alternating vertical and horizontal lines that accurately show sandstone block construction. A broad flight of steps in the middle ascends the wall. Towers at either end mark the two southern corners of the garden. Next to the southeast tower is a Persian inscription reading "Mahtab Burj" (tower). The towers are octagonal and triple-storied, with bottom blank stages, intermediate arcades, and upper octagonal pavilions, exactly as in the surviving example in the southeast corner of the garden (fig. 3). No walls are indicated on the other three sides of the garden, nor are there any towers at the two northern corners. A pavilion in the middle of the enclosure, a short distance above (north) the riverfront wall, appears to have a central chamber entered through a triple arcade and roofed with a vault, flanked by smaller chambers topped with fluted domes. An inscription identifies it as "Bangla Mahtab." A few cows and goats, and an occasional shepherd, populate the surrounding grassy wasteland.[2]

Figure 1. Detail, map of Agra, India, first half 18th century. Cloth, 292 x 272 cm, Maharaja Sawai Man Singh II City Palace Museum, Jaipur, Rajasthan. Used by permission. This map covers the whole town, with emphasis on parts requiring repair or construction. The Taj Mahal is in the lower center of the map, on the south bank of the Yamuna river, with the Mahtab Bagh on the opposite, north bank.

Figure 2. Detail, map of the Taj Mahal, India, early 19th century. Watercolor on cloth, approx. 1 x 3 m. Taj Museum, Agra. Reproduced by permission of the Archaeological Survey of India. Photograph by Neil Greentree. This detail shows the riverside wall with steps and the "Bangla Mahtab" pavilion in the middle of the garden.

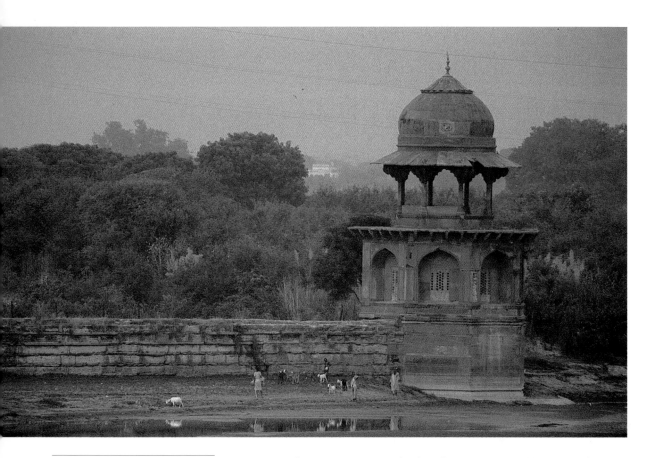

Figure 3. Surviving tower, southeast corner,
Mahtab Bagh, 1999. Photograph by Neil
Greentree

Another map we consulted is from a 1789 publication showing
views of the Taj and the city of Agra, now in the British Library (see
p. 37). This architectural plan, which is scaled in *guz,* the traditional
Mughal measurement, shows the southern part of the Mahtab Bagh divided into approxi-
mately regular planted squares separated by axial walkways. The riverfront wall running
between the corner octagonal towers has a slight projection in the middle. Set back a short
distance from this wall is a pavilion with a central chamber with triple openings front and
back, and square side chambers. The pavilion stands on a terrace, with a small square pool to
the south.[3]

## THE SITE AND ITS LAYOUT

From these cartographic representations of the the Mahtab Bagh, we now turn to the site
itself.[4] It is situated on the north bank of the Yamuna, at a point where the river makes a
deep bend to the east. It is opposite the higher south bank, where the Taj is elevated on a
substantial masonry terrace. The garden is built on deep alluvial deposits of interbedded
silts and sand that are easily moved by wind and water, processes that continue to this day.
The surface of the Mahtab Bagh is higher than that of the plantations that surround it on
the east, north, and west, as well as the sediments deposited against the south wall. The site
slopes noticeably from north to south, conforming to the natural bank of the river, which at

this point is about 6 meters beneath the highest point of the garden. Changes of level on the east, north, and west sides of the site suggest the line of the original walls.[5] Layers of sand forming undulating dunes on silt provide an ideal habitat for the thick growth of river grass that is harvested annually by local villagers. These people may also have been responsible for destructive mining.[6]

Though dunes and grass covered most of the site during fieldwork in 1996 (fig. 4), thereby severely hampering the work of the archaeologists, they did not entirely conceal all the garden's original features. The first thing we observed is that the Mahtab Bagh is coordinated with the enclosure containing the Taj Mahal: the width of the garden is nearly the same as that of the Taj. Significantly, both complexes share a common north-south axis; furthermore, each is raised on a riverfront terrace with a lower *charbagh* to the rear. (*Charbagh*, literally "fourfold garden," is the standard Persian term for a walled garden with axial paths that create four planted plots.) In this respect, the layouts of the Mahtab Bagh and the Taj are mirror images (see Site Plan, p. 33–36).

The Mahtab Bagh occupies a square area, the southern boundary of which is marked by a riverfront wall with corner towers, only one of which still stands (see fig. 3). A portion of the east enclosure wall is visible, but the walls that we assume contained the garden on the other sides, together with the towers that marked the two northern corners, could not be seen prior to excavation. The main access to the garden was from the river, where a landing platform was provided beside the water. Collapsed remains immediately inside the riverfront wall hint at a once-elevated platform with chambers. We also found indications of a gateway in the middle of the north side of the garden and a pavilion in the corresponding position on the east.

The interior of the Mahtab Bagh is divided into two unequal zones. An elevated terrace abutting the riverfront wall, some 60 meters across, dominates the southern part of the garden. Yet the terrace does not extend the full width to the eastern and western extremities of the site; a drop in level on these sides suggests that the terrace was flanked by lower areas that were possibly reserved for planting. In the middle of the elevated terrace is an octagonal pool, the largest observable feature of the Mahtab Bagh, and, we believe, the most significant in terms of the garden's original purpose. Structural remains on the north side of the terrace indicate a pavilion overlooking the pool.

The northern part of the garden, measuring approximately 300 by 220 meters, and also set at a slightly lower level, contained a *charbagh*, but only after clearing could we observe any garden features. What we calculate to be the center point of the *charbagh* is marked by a modern memorial known as a *samadhi*; a revenue map suggests that an abandoned well was also located here.[7] These features are axially aligned with the remains of the gateway on the north side of the garden and the pavilion abutting the east enclosure wall.

## WALLS AND TOWERS

The riverfront wall is the only boundary of the Mahtab Bagh that we can observe above its foundations (see fig. 5). About 225 meters of its original 308-meter length extend westward from the southeast tower. The outer face of the wall, best preserved at its eastern end, has six bands of alternating horizontal and vertical slabs of red sandstone, the latter almost all robbed.[8] Except for the odd piece, the capping sandstone slabs of the wall are also lost, thereby exposing the 2-meter-wide brick core. Nor did we find any evidence of sandstone

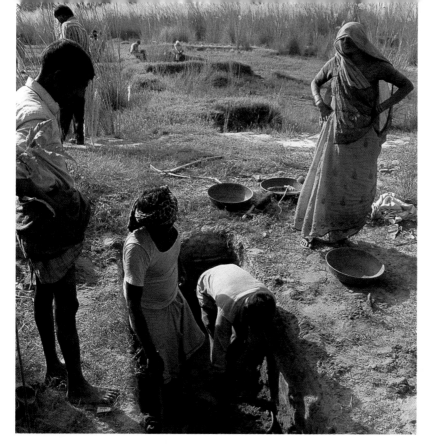

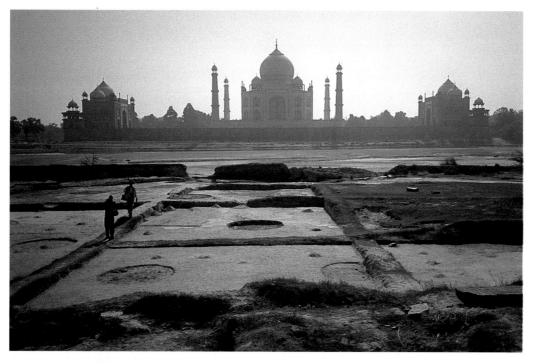

Figure 4. Tall *phuse* grass obscuring the features of the Mahtab Bagh, 1999. Photograph by Neil Greentree

Figure 5. The dilapidated riverside wall, with the octagonal tower at the southeast corner, 1999. Photograph by Neil Greentree

Figure 6. Workers at the Mahtab Bagh site, 1996. Photograph by John Henry Rice

Figure 7. The excavations of the octagonal pool on the riverside terrace, with the Taj Mahal in the distance, 1995. Photograph by Elizabeth Moynihan

cladding on the wall's inside face. An intriguing feature is the pair of brick arches built into the base of the wall in the middle of its eastern half. These arches may have facilitated the drainage of water from the garden into the river.

The banded sandstone wall of the Mahtab Bagh is typical of Mughal architecture; so, too, is the octagonal corner tower that projects beyond its eastern extremity. The lowest stage of the tower continues the molded footing and banded facing slabs of the riverfront wall but is terminated by a molded cornice incorporating a frieze of well-finished pendant

Figure 8. Dilapidated sandstone lobe from
the octagonal pool on the riverside terrace,
1999. Photograph by Neil Greentree

petals. The intermediate stage consists of an octagonal domed chamber with plain arched openings set into rectangular frames on each side. The walls here also rise on a molded basement, the top course of which repeats the petaled frieze from beneath. At the top of the walls is a line of brackets with curved profiles, one at each corner and four in between; they carry an overhang with a petaled frieze running along the edge. On the interior, the arched openings are topped with a shallow net pattern that serves as a transition to the circular base of the dome. The dome itself is lined with two sets of curving slabs separated by a ring, with two half-circular pieces at the apex. The floor slabs of the chamber are missing, exposing the brick and concrete substructure.

The topmost stage of the tower is an octagonal open domed pavilion at rooftop level, known in Mughal architectural terminology as a *chhatri*. As there is no evidence of any staircase, we presume that access to this level was by ladder. The pavilion stands on an octagonal platform formed by the overhang of the stage beneath. Eight polygonal columns rise on tapering bases adorned with stylized flowers. Balustrades with shallow panels on the outer faces survive on four sides, but not on the north, where there are three small steps. Vertical slabs cut into arched profiles with seven lobes are set between the columns, while triple brackets with curved profiles project outward from each column. The brackets carry a plain overhang on which rises a slightly bulbous dome capped with a finial with twenty-four flowing petals. The dome is faced both outside and inside with alternating vertical and horizontal courses.

The surviving southeast tower corresponds in all essential respects with those shown on the Taj Museum map, but an identical tower, shown on the map at the southwest corner,

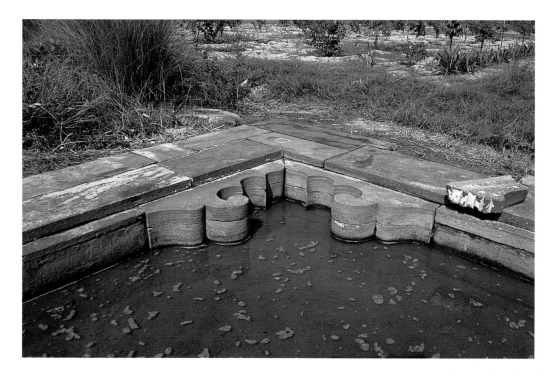

is today only an octagonal mass of mortared brickwork, without any facing stones, situated outside the Archaeological Survey of India precinct. So far as we could observe, the two towers of the Mahtab Bagh are perfectly centered with those marking the northern corners of the Taj enclosure.[9]

Nothing of the north and west perimeter walls of the garden can be seen except for a fragment of mortared brickwork running northward from the southeast tower. That such walls once existed is suggested by the British Library plan (see p. 37), and traces of the base of the east wall were revealed in the recent excavations. We believe that the partial preservation of the riverfront wall may best be explained by its more substantial construction, doubtless intended to withstand flooding. Moreover the villagers, realizing that this wall protected their fields from erosion, may have refrained from pillaging it.

As we have noted already, the Jaipur City Palace Museum map of Agra (see fig. 1) shows a triple-chambered, vaulted pavilion on top of the middle of the riverfront wall. While such a pavilion is not confirmed by the archaeological record, there is evidence that a sandstone structure did indeed crown the wall at this point. Remains of a collapsed brick vault indicate that the wall was originally thickened on its inner face, with a narrow chamber beneath. This vault originally supported a red sandstone pavement with small chambers at either end, remnants of which can be seen lying below. The sides of the pavement consist of a frieze of pendant buds on a vertical course. At the eastern end of the pavement are indications of a wall and window of a small chamber, which we presume was matched by another chamber at the western end.[10] Two steps leading up to the platform from the north provided

Figure 10. Decaying pylon from the waterworks associated with the Mahtab Bagh, 1999. Photograph by Neil Greentree.

access from the terrace surrounding the pool. The landing platform that extended southward from the riverfront wall, shown in the same map, is now reduced to an expanse of brickwork eroding from the sandy bank.[11]

## POOL, TERRACE, AND PAVILION

The southern part of the Mahtab Bagh is dominated by a raised terrace with a large central pool, both octagonal in layout. These features are located on the central north-south axis of the garden and, by extension, of the Taj complex itself (see figs. 6, 7). Until exposed by the archaeologists, both terrace and pool were buried; that explains their conspicuous absence in the maps we consulted. These features were not always hidden from view, however, and there is the intriguing possibility that when the Mahtab Bagh was abandoned and began to deteriorate, the octagonal outline of the terrace and central depression of the pool came to be misunderstood by visitors as the foundations of an incomplete structure: hence the myth of the second Taj.[12]

As revealed by the archaeologists, the pool is incompletely preserved, especially on the south side where the terrace containing it was rendered more vulnerable because of the vaulting between it and the riverside wall. As a result, the terrace has been undermined by floodwaters and has partly collapsed. Even so, we can easily determine its overall form thanks to the geometric regularity of its design. The pool occupies an octagonal depression in the middle of a massive octagonal supporting structure. The floor of the pool is formed by plaster layers on a bed of concrete pierced by twenty-four circular holes arranged in two concentric rings around a central hole.[13] Fragments of terracotta pipes were found inside the holes, confirming that they once functioned as fountains; marble spouts with red sandstone bases were also recovered. The impressive dimensions of the pool and its prominent location in the middle of the raised terrace clearly make it the most important feature of the garden.[14]

The beauty of the pool is enhanced by its ornate decoration. The sides consist of two shelves, one set back from the other, the upper shelf taking the form of a multipetaled fringe with trilobed projections alternating with five-lobed indentations (see fig. 8).[15] There were sixteen such petaled projections on each side of the octagon, but nowhere is a full set preserved. Since this petaled fringe marked the edge of the pool, the lobed tips would have appeared to float in the water. Except on the south side, most of the red sandstone caps of these lobes are lost.

The skeleton of the wide terrace that surrounds the pool is fully exposed. Its surface is best preserved on the south, where the fragment that subsided was protected by sediments. Here the terrace is surfaced with plastered concrete and edged with a single course of thin red sandstone with a simple molding, set back and above the petaled fringe of the pool. Elsewhere the surface and transitional stone course are lost; all we can now see is the brick core of the terrace, with occasional subfloor drains, such as the plaster-lined example on the southeast. The construction of the terrace is of interest. Excavations show it is divided into two octagonal rings, separated by a deep trench covered with a thick layer of concrete and brick.[16] The trench is filled with layers of building debris and sediments different from those occurring naturally in the site. It has a brick-lined, sloping bottom surface that joins the two rings.[17] This feature would have directed excess water away from the central part of the terrace, while the massive structure ensured additional strength in floods.

Except for a pavilion on the north side, there is no evidence of any structures on the terrace. However, small watercourses may have extended across the terrace (perhaps below its surface) on east and west axes. A small pool below the terrace abuts its west side; we can imagine a vertical cascade set against the terrace that conducted water into the pool. The extensively robbed brick and stone foundations of the north pavilion are set back from the edge of the pool. Bases of brick walls, impressions of floor slabs, and a sandstone foundation course on the south and west indicate a rectangular chamber flanked by smaller square chambers, arranged in an east-west line.[18] Exactly this configuration is depicted in the "Bangla Mahtab" of the Taj Museum map (see fig. 2); a similar layout is indicated in the more precisely rendered British Library plan (see p. 37).[19] Isolated sandstone elements, including two finely carved segments of an arch with a gently curved profile, were found lying in the dirt near the northeast and southwest sides of the terrace. They probably belong to the central *bangla* roofed chamber.[20]

Clearing work in and around the pavilion has uncovered important evidence of the intricate water system with which the Mahtab Bagh was once supplied.[21] A broad, red sandstone-lined channel set into the floor of the central chamber of the pavilion conducted water from the octagonal pool to a vertical cascade immediately to the north. The rear wall of the cascade was lined with triple tiers of nine niches, presumably for lamps. After being collected in a large and well-preserved rectangular pool with sandstone corner lobes (see fig. 9) and set in an encircling sandstone terrace beneath the pavilion, the water was carried by channels on three sides into the *charbagh* area[22] (see "Waterworks and Landscape Design").

## THE CHARBAGH

Unfortunately, the features of the *charbagh* that constitute the northern part of the Mahtab Bagh are much less well preserved than the octagonal terrace and pool. Here the excavators

have located the foundations of the gateway and pavilion that terminated the north and east axes of the garden respectively, as well as the pool that marked its center point. Only elusive traces remain of the walkways and water channels that divided the garden into regularly shaped, planted plots.

Before excavation, the sole indications of the north gateway were two exposed areas of brickwork separated by a 3.9-meter gap, presumed to be an entryway, set into the ground. Clearance exposed the foundations of a large rectangular structure, originally faced with a sandstone veneer. Similar areas of brickwork were visible on the surface of a mound on the east side of the *charbagh*. Here the archaeologists uncovered the brick foundations of a large rectangular pavilion as well as the base of the east enclosure wall it abutted.[23] Both had been systematically robbed for building materials; discarded sediments and materials discovered in the excavation trenches revealed three distinct episodes of demolition and quarrying. The remains of the rectangular pavilion preserve impressions of stone cladding on the outer walls. A sandstone piece fashioned as a half multilobed arch with a twisted rope design was found lying on the ground; the other half was recovered in the excavations. They may have framed the central entry of the pavilion.

More rewarding from the point of view of the *charbagh* design of the Mahtab Bagh was the excavation conducted in the middle of the garden. Here the archaeologists found the plastered brick remains of a square pool with angled corners containing petaled lobes similar to those of the large octagonal pool. No sandstone covering slabs were preserved. The pool is raised on a square brick platform with signs of projecting brickwork in the middle of the south and west sides that indicate the beginnings of axial watercourses. (The central pool in the *charbagh* of the Taj Mahal is also raised on a terrace above the level of the garden; here, however, the pool is square, as is its surrounding terrace.)

WATERWORKS

Our account of architectural features must include the dilapidated brick structures that stand outside the enclosure, near the ruined southwest tower. No Mughal garden could function without waterworks, which introduced water at a higher level so as to achieve sufficient pressure to drive the fountains and propel the water through channels at different lower levels.[24]

Of the waterworks at the Mahtab Bagh, all that can now be seen is a line of five decaying brick pylons. The first, most easterly pylon abuts the modern whitewashed structure that currently serves as an ashram and probably marks the site of the west perimeter wall of the garden. The most significant feature to survive is the cistern raised up on a vault carried by the first two pylons.[25] It consists of a rectangular basin with angled corners and plaster-lined floor and walls. Among the hydraulic devices that we could see here are terracotta pipes, a circular sandstone outlet, and a sandstone grille with hexagonal openings.

Only the lower parts of the second and third pylons still stand. By analogy with the waterworks of the Taj enclosure, they would have carried an elevated channel. The bases of the pylons are pierced by a large hole, as if to house a terracotta pipe or wooden pole, now lost. A circular well, 2.5 meters in diameter, is located immediately to the south, near heaps of collapsed brickwork. Little remains of the fourth pylon. The fifth pylon, isolated in a field some 30 meters to the west, sits on a pair of cylindrical footings created in massive masonry (see fig. 10). Square holes in its upper portions suggest water outlets.

## THE MAHTAB BAGH AND OTHER GARDENS

The Mahtab Bagh's place in the history of Mughal garden design depends more on its unique layout than on the formal aspects of its architectural components. The garden's river-front wall and surviving tower, the raised terrace with its central pool, the north pavilion and associated hydraulic features, and even the waterworks standing outside the enclosure are typical of the era's building materials, construction, and decoration. So is the overall division of the garden into a raised terrace overlooking the Yamuna River and a lower *charbagh* to the rear. This layout is the standard pattern of riverfront gardens at Agra,[26] nowhere better shown than in the Ram Bagh, some 4 kilometers upstream. This comparatively well pre-served complex has pavilions distributed around a small pool elevated on a terrace, while to the rear is a square *charbagh*, complete with paved pathways, stone-lined channels, and a cen-tral zone for a fountain or pavilion.[27]

The Ram Bagh is earlier than the Mahtab Bagh, being a commission of Nurjahan, wife of Jahangir, after whom it was originally named Bagh-i Nurasfahan. While the Ram Bagh might have served as a model for the Mahtab Bagh, there are significant differences between the two schemes, the most important being the Mahtab Bagh's octagonal riverfront terrace and pool and the rectangular *charbagh* to the rear. Octagonal pools are common in Mughal gar-den design, and examples with petaled fringes are known from the garden laid out by Babur at Dholpur,[28] to pools associated with palaces and tombs founded by Jahangir and Shahjahan at localities in and around Agra and Lahore in the first half of the seventeenth century.

Such comparisons only accentuate the originality of the Mahtab Bagh, for no other garden of the period is dominated by such a large octagonal body of water. Seated in their pleasure pavilion on the edge of the octagonal pool, Shahjahan and his companions could have comfortably enjoyed the sprays of water thrown up by the twenty-five fountains. A full view of the Taj would have appeared beyond the sprays, since the floor level of the pavilion was higher than the top of the riverfront wall. Framed by the small chambers on the river-front wall, the Taj's majestic elevation would have seemed to float in the middle of the sky, a vision still awe-inspiring to contemplate. ◉

## NOTES

Our observations on the Mahtab Bagh are based on field-work conducted in November 1996 in collaboration with Elizabeth B. Moynihan and David Lentz, as well as with P. B. S. Sengar, superintending archaeologist of the Agra Circle of the Archaeological Survey of India (ASI) and members of his staff, in particular N. Shrivatsa and O. D. Shukla. Subsequent visits to the site were made in 1997 and 1999 following the clearance of many structures described here.

1. The Maharaja Sawai Man Singh II Museum map is published in Susan Gole, *Indian Maps and Plans: From the Earliest Times to the Advent of European Surveys* (New Delhi: Manohar, 1989), pp. 199–201.

2. The term *bangla* refers to a vault with a distinctive curved ridge and cornice derived from the bamboo and thatch huts of Bengal. Introduced during Shahjahan's reign when they were reserved for the emperor and his family, such vaulted forms became popular with Mughal architects, especially for palace and garden pavilions.

3. Another pictorial source of interest for our understanding of the Mahtab Bagh is the detail of *The Delivery of Presents for Prince Dara-Shikoh's Wedding*, illustrated on pages 58 and 67, which shows architectural features on the bank of the Yamuna River. Many of these may be compared with the remains of the Mahtab Bagh, especially the red sandstone riverfront wall, the multistage octagonal towers topped by *chhatris*, the landing stage with a flat-roofed pavilion above, and the tower and elevated channel of the associated waterworks. Significantly, these features are not portrayed in the same spatial sequence as those of the Mahtab Bagh. The waterworks of the Mahtab Bagh, for instance, lie to the west of the landing stage; that is, to the left as seen from the opposite bank: here they appear to the right. Our conclusion, then, is that this painting does not represent the Mahtab Bagh, but rather a typical riverfront garden, perhaps one of the many at Agra that have now disappeared.

4. As defined by the ASI, the Mahtab Bagh site consists of a square zone approximately 308 meters on side, delimited by a barbed-wire fence on the east, north, and west, and the remains of the original riverfront wall on the south. A guava plantation is situated near the southwest corner of the site; here a grove of trees provides shade for a simple modern building serving as an ashram and a number of memorials, or *samadhis*. A disused toilet block stands near the northwest corner

of the site. Numerous trees are scattered in and around the site, some of which were planted as part of a reforestation program by the Horticultural Branch of the ASI. A track running along the west side of the site leads from the river to nearby villages.

5. This slope does not always coincide with the barbed-wire fence, and the probable west side of the garden lies well outside it.

6. One of the most extensive instances of quarrying is a pit some 80 by 35 meters, and 3 meters deep, next to the inner face of the riverfront wall. Lesser pits are seen near the southwestern corner of the garden and in the eastern half of the site.

7. Map in ASI office, Agra. Subsequent ASI excavations showed that the well was in fact the remains of a pool in the middle of the garden.

8. At its most complete, the wall rises to a height of 3.65 meters above a triple-molded footing, itself some 85 centimeters high where fully exposed at the eastern end of the wall.

9. A compass reading from the middle of the southeast Mahtab Bagh tower to the middle of its counterpart in the Taj enclosure measured 179 degrees—that is, almost exactly north-south. However, the enclosure walls in both complexes adjoin the corners of the towers, not their center points. Since the Mahtab Bagh tower is smaller than the Taj tower, the Mahtab Bagh enclosure is a few meters narrower than that of the Taj.

10. Part of the sill with a raised block to seat a door pivot is preserved on the north edge of the floor; a stone lintel and door frame lie in rubble nearby. Lines of small sockets that may have seated a railing or screen occur on the east edge and at the probable west side of the structure. A lintel and two jambs found in the debris almost certainly come from one of these chambers, possibly also the nearby column bases, capitals, and impost blocks. An idea of the possible appearance of this structure may be had from the pavilion above the riverside landing stage depicted in *The Delivery of Presents for Prince Dara-Shikoh's Wedding*, illustrated on pages 58 and 67.

11. A. C. L. Carlleyle, *Agra: Report for the Year 1871–1872*, vol.4 (Reprint, Varanasi: Indological Book House, 1966), p. 181, gives overall dimensions of the platform as 80 by 39 feet (24.4 x 11.9 m), and specifies that steps from it descended to the water on each side.

12. Ibid.

13. The holes range from 2.1 to 2.4 meters in diameter. There were originally sixteen holes in the outer ring, eight holes in the inner ring, and a central hole, for a total of twenty-five holes. In 1996, only fifteen of these were exposed.

14. The octagonal pool is 17.3 meters long on each side, yielding an overall diameter of 41.8 meters. The supporting octagonal terrace is more than 8.6 meters wide on each side.

15. The length of each lobed projection is 85 centimeters, with a maximum width of 48 centimeters between the lobes; the petaled tips of the projections are 114 to 118 centimeters apart, varying slightly at the corners where they frame indentations set at an angle of 45 degrees. The petaled projections have 10-centimeter-thick, red sandstone capping pieces on 40-centimeter bases of plaster-lined, mortared brick.

16. The trench, which is 2.3 meters wide and some 3.8 meters deep where fully exposed, separates the 4.3-meter-wide inner part of the terrace from the 2.0-meter-wide outer part.

17. The sediments consist of layers of compacted clay loam, with varying sand content, which becomes wetter toward the bottom. At least six layers (a deposit with a lens-shaped cross section) of decomposed mortar mixed with brickbats extended from the wall of the terrace into these sediments. Brickbats, lumps of mortar, fragments of red sandstone, shards, and animal bone were also found in the fill; some may have been deposited after floodwaters scoured the top of the trench. The inner wall of the trench consists of three segments of well-coursed bricks, each projecting outward a few centimeters from the one below. Our examination of the trench wall revealed six phases of construction, beginning with the preparation of the natural sediments more than 4 meters below the surface of the terrace and ending with the addition of the concrete capping on top.

18. These indicate a pavilion with end chambers about 5 meters wide, separated by a central chamber some 8 meters wide; the depth of the building is 3.2 meters.

19. The pavilion shown on top of the riverfront wall of the Jaipur Museum map also seems to be of this type.

Indeed, it is possible that it is intended to represent exactly the same structure, not planimetrically, in the middle of the garden, but elevationally, as it might have appeared hovering over the top of the riverfront wall.

20. The floor level of the pavilion is about 50 centimeters higher than that of the terrace and is virtually the same height as the highest point of the riverfront wall, though this wall is now lacking its capping pieces. Such measurements indicate that the pavilion would have risen above the top of the riverfront wall, permitting an uninterrupted view of the Taj.

21. This work took place after our initial fieldwork in November 1996.

22. James L. Wescoat Jr. has suggested that these outlets may have led to channels that encircled the terrace before leading into the surrounding gardens. See "Waterworks and Landscape Design."

23. The 1.9-meter-wide base of the enclosure wall was discovered at a depth of 2.3 meters.

24. The dilapidated waterworks of the Taj, also situated near to the southwest corner of the complex, give a good idea of the Mughal hydraulic system.

25. Elevated 3.5 meters above the ground, the cistern measures 3.0 by 2.85 meters; its walls are 1.65 meters high. The supporting pylons, now much eroded, measure about 4.5 by 1.0 meters.

26. Once again, the Jaipur museum map of Agra (see fig. 1) is instructive, since it depicts the Yamuna lined with garden enclosures on both banks. Only a few of these survive today, and most in an advanced state of decay. For a discussion of the typology of these gardens, see Ebba Koch, "The Mughal Waterfront Garden," in *Gardens in the Time of the Great Muslim Empires: Theory and Design*, ed. Attilio Petruccioli (Leiden: E. J. Brill 1996), pp. 140–60.

27. Ebba Koch, "Notes on the Painted and Sculptured Decoration of Nur Jahan's Pavilions in the Ram Bagh (Bagh-i Nur Afshan) at Agra," in "Facets of Indian Art, ed., R. Skelton et al. (London: Victoria and Albert Museum, 1986), pp. 51–65.

28. Elizabeth B. Moynihan, "The Lotus Garden Palace of Babur," in *Muqarnas* 5 (1988): pp. 135–52.

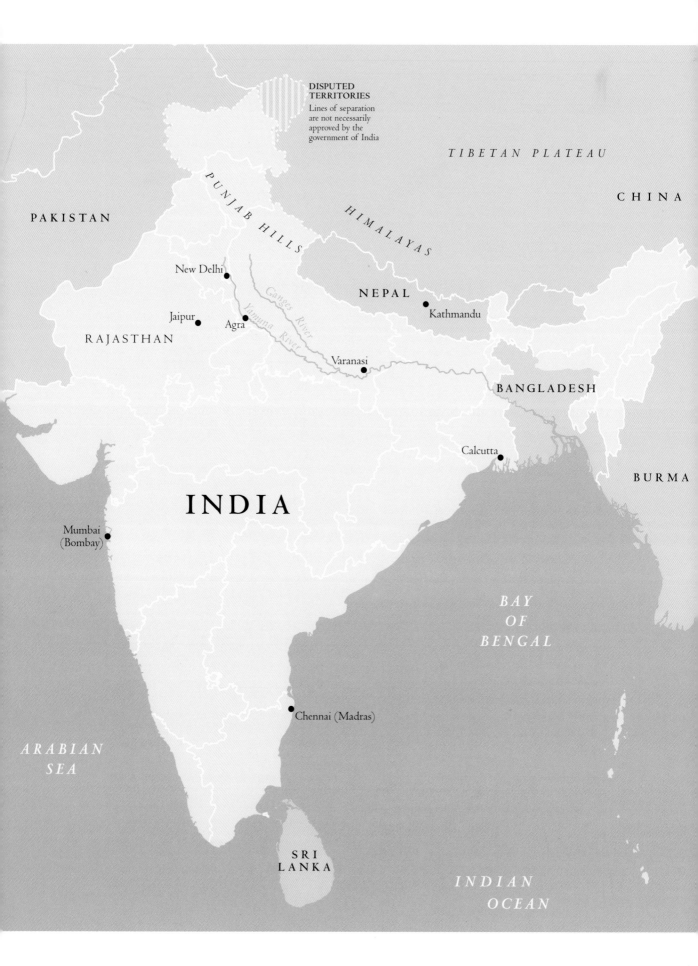

DISPUTED
TERRITORIES
Lines of separation
are not necessarily
approved by the
government of India

*TIBETAN PLATEAU*

CHINA

PAKISTAN

*PUNJAB HILLS*

*HIMALAYAS*

New Delhi

*Ganges River*

NEPAL

Kathmandu

Jaipur

Agra

*Yamuna River*

RAJASTHAN

Varanasi

BANGLADESH

Calcutta

BURMA

# INDIA

Mumbai
(Bombay)

*BAY
OF
BENGAL*

Chennai (Madras)

*ARABIAN
SEA*

SRI
LANKA

*INDIAN
OCEAN*

# CHRONOLOGY OF MUGHAL EMPERORS

Babur

1483–1530; reigned 1526–1530

---

Humayun

1508–1556; reigned 1530–1540; 1555–1556

---

Akbar

1542–1605; reigned 1556–1605

---

Jahangir

1569–1627; reigned 1605–1627

---

Shahjahan

1592–1666; reigned 1628–1658

---

Aurangzeb

1618–1707; reigned 1658–1707

---

Bahadur Shah

1643–1712; reigned 1707–1712

---

Farrukhsiyar

1683–1719; reigned 1713–1719

---

Muhammad Shah

1702–1748; reigned 1719–1748

Source: Milo Cleveland Beach, Ebba Koch, and Wheeler M. Thackston, *King of the World: The Padshahnama, An Imperial Mughal Manuscript from the Royal Library, Windsor Castle* (London: Azimuth Editions; and Washington, D.C.: Arthur M. Sackler Gallery, 1997), p. 16.

# FURTHER READING

Al-Hassan, Ahmad Y., and Donald R. Hill. *Islamic Technology: An Illustrated History.* Cambridge: Cambridge University Press, 1986.

A rich survey of water-raising machines, water clocks, fountains, irrigation, and dams set within a broad historical perspective on science and engineering in Muslim societies.

Blair, Sheila S., and Jonathan M. Bloom. *The Art and Architecture of Islam, 1250–1800.* New Haven and London: Yale University Press, 1994.

Includes chapters on India that provide a context for the development of Mughal architecture in India and other chapters that survey Islamic art and architecture at the time.

Blair, Sheila S., and Jonathan M. Bloom, eds. *Images of Paradise in Islamic Art.* Hanover, N.H.: Hood Museum of Art, Dartmouth College, 1991.

Exhibition catalogue that illustrates how the imagery of paradise permeated Islamic art. The essays discuss various interpretations of the theme, but all agree that understanding the koranic paradise is necessary to understanding the Islamic paradise.

Chowdury, K. A., and S. S. Ghosh. *Indian Woods.* Delhi: Survey of India, Dehra Dun, 1958.

A four-volume set of anatomical descriptions and micrographs of the woody species of India.

Gascoigne, Bamber. *The Great Moghuls.* London: Jonathan Cape, 1971.

A history of the early great Mughals that conveys an impression of the personalities and styles of the emperors and their time. The book is richly illustrated and accessible for the general reader.

Koch, Ebba. *Mughal Architecture.* Munich: Prestel-Verlag, 1991.

A scholarly but concise history of the sources and development of Mughal architecture. Based on research on original documents and extensive fieldwork and illustrated with plans, sketches, and many photographs.

Patnaik, Naveen. *The Garden of Life: An Introduction to the Healing Plants of India.* London: Harper Collins Publishers, 1993.

A beautifully illustrated text describing some of the common medicinal plants from the Indian subcontinent.

Purkayastha, S. K. *A Manual of Indian Timbers.* Calcutta: Sribhumi Publishing Company, 1997.

An updated version of the original pioneering treatise by J. S. Gamble. It includes a description of many of the trees common in India.

Sahni, K. C. *The Book of Indian Trees.* Delhi: Oxford University Press, 1998.

Excellent botanical illustrations with field identification characters for many arboreal species of India.

Tabbaa, Yasser. "The Medieval Islamic Garden: Typology and Hydraulics." In *Garden History: Issues, Approaches, Methods,* edited by John Dixon Hunt, pp. 303–30. Washington, D.C.: Dumbarton Oaks, 1989.

A theoretical essay on the aesthetics and symbolism of garden waterworks with examples from Spain and Sicily to Iraq and Afghanistan. The larger volume offers comparative perspectives on garden history.

Villiers Stuart, Constance M. *Gardens of the Great Mughals.* London: Adam and Charles Black, 1913.

A perceptive and charmingly written memoir of the ruins of some of the great Mughal gardens by an English visitor. The earliest account of the gardens, it is well researched and illustrated by the author's watercolors.

Wilber, Donald N. *Persian Gardens and Garden Pavilions.* Rutland, Vt.: Charles E. Tuttle, 1962.

The first scholarly approach to the study of the paradise garden, describing its development in Iran. This book, which includes plans and photographs, sparked the current interest in Islamic gardens.

# CONTRIBUTORS

ELIZABETH B. MOYNIHAN studied architectural history at Harvard University. In India in 1973–74, she undertook a survey of surviving Mughal gardens that became the basis of her book *Paradise as a Garden in Persia and Mughal India* (New York: George Braziller, 1979). In 1978 she discovered the previously unknown Lotus Garden of the Emperor Babur and has since identified three additional sites mentioned in his autobiography, *The Babur Nama*. She was a member of the Indo-U.S. Sub-Commission on Education and Culture, currently a trustee of the National Building Museum, and serves on the Visiting Committee of the Arthur M. Sackler Gallery.

JOHN M. FRITZ began research in southern India in 1981 on the symbolism of the urban layout of the fourteenth–sixteenth century imperial capital, Vijayanagara. He is adjunct associate professor of anthropology at the University of Pennsylvania and has taught at the University of California, Santa Cruz, and at the State University of New York, Binghamton. Together with George Michell and the photographer John Gollings, he has published *City of Victory: Vijayanagara, the Medieval Capital of Southern India* (New York: Aperture, 1991).

DAVID L. LENTZ is director of the Graduate Studies Program at the New York Botanical Garden. He serves as an instructor and adjunct faculty member at Columbia University, the City University of New York, New York University, and Yale University. His area of expertise is paleoethnobotany, and his research focuses on the past uses of plants in Central Asia and Mesoamerica. He edited a volume entitled *Imperfect Balance: Landscape Transformations in the Precolumbian Americas* (New York: Columbia University Press, 2000), which examines the modifying effects of ancient land use practices in the Western Hemisphere.

GEORGE MICHELL was trained as an architect in Melbourne, Australia, and then went on to study Indian archaeology at the University of London. He has worked on various documentation projects in India, most notably at Vijayanagara with John Fritz. Among his recent publications are: *Architecture and Art of Southern India, Vijayanagara and the Successor States* (1995), and, together with Mark Zebrowski, *Architecture and Art of the Deccan Sultanates* (1999), both in the New Cambridge History of India series.

JAMES L. WESCOAT JR. is professor of geography at the University of Colorado at Boulder, where he teaches courses on the history and theory of geography and water resources in South Asia and the American West. He directed the Mughal Garden Project in Lahore, Pakistan, from 1986 to 1996. He and colleagues on that project coedited several books on Mughal gardens including, *Mughal Gardens: Sources, Places, Representations, and Prospects* (Washington, D.C.: Dumbarton Oaks, 1996); *The Mughal Garden: Interpretation, Conservation, Implications* (Ferozsons Ltd., 1996); and *Mughal Gardens in Lahore: History and Documentation* (University of Engineering and Technology, Lahore, 1996). His subsequent research focuses on water in landscape design and planning.